THE SECRET WOOD

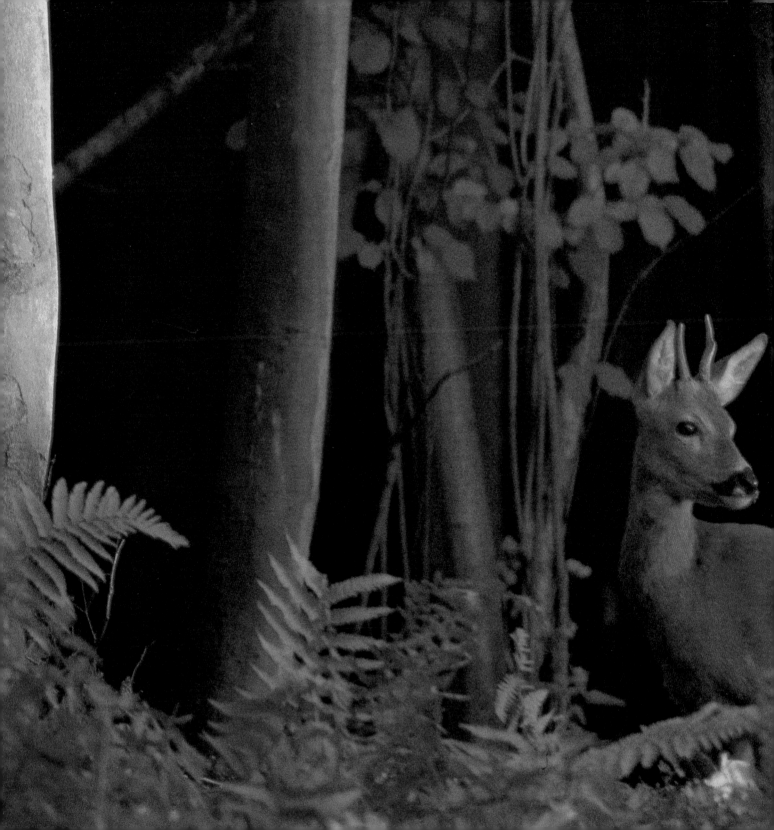

Spirit of Nature

The Secret Wood

David Boag

A LION BOOK

Introduction

We usually think of the woodland as being a natural habitat — it is often referred to as the 'wild wood'. In fact, only a handful of truly wild woods exist. Most ancient woodland has been managed by people at some stage in its history. Much has been felled and re-planted, some has been coppiced for many generations, and other areas have been pollarded and grazed. In the past, many people's lives revolved around the woods and it is only in recent years that we have come to value them as places of recreation as well as work. Today, woodland is often managed for its wildlife as well as its timber, which is a both complicated and skilful task due to the delicate balance that exists between countless different species of plants, insects, birds and mammals. At one time the wild woods covered most of the British Isles, but now each wood is a comparatively small, isolated area. Management is important to enable, or limit, human access and to encourage diversity that has been lost as a result of its isolation. So even today woodland is not truly wild but a habitat managed in the way humans choose.

Ever since humans first walked through the woods, they were places of magic and mystery. As a result, many myths and legends were woven around the ancient trees and the wildlife that inhabits the secret depths of the forest. In some respects it is a shame that we have discovered how so many things in the natural world take place. Our logical and scientific minds are able to explain away all the old myths and very little takes us by surprise.

Sometimes our intellect dulls our ability to enthuse about the design of a dandelion seed head or wonder at the relationship between predator and prey. Rain or frost becomes commonplace; we expect buds to appear on the trees every spring and insects to visit the flowers.

4

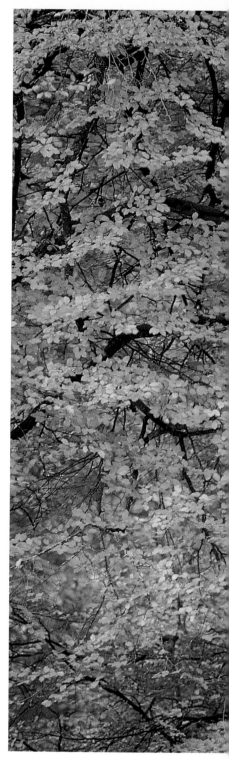

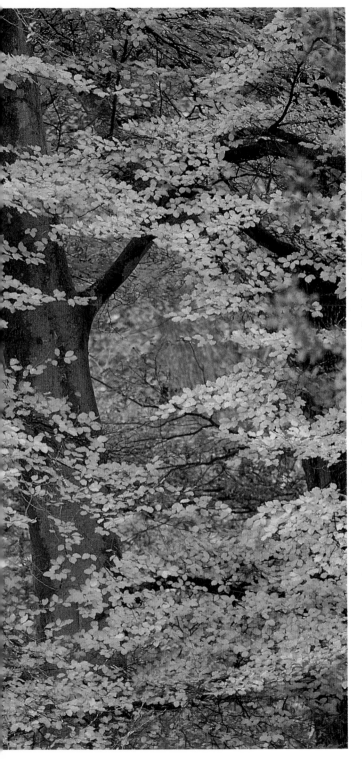

It is difficult to enthuse about a bird that migrates as a result of an 'innate propensity to certain seemingly rational acts performed without conscious intention' (a dictionary definition of 'instinct'!). But consider a redstart that leaves the wood when only a few weeks old. It flies hundreds of miles directly to its wintering grounds in tropical Africa, with no idea of its destination. The following spring it will retrace its route until it arrives, not only in Britain, but probably into the wood of its birth. For me, miracles still take place.

I maintain my enthusiasm of the natural world, not out of ignorance, but out of a sense of awe and wonder that these things exist. Within it all I see the work of God who not only created the woodland and the creatures within it but also gave humans the ability to understand and enjoy the world which surrounds them. The more I wander in the woods, and photograph, study and write about its life, the less I feel I understand. The more knowledge I gain, the more questions arise. Although sometimes I find it frustrating, I cannot help returning to the woods to be excited by new and interesting things. I hope within the pages of this book I can enthuse you with some of the wonders of creation that I have discovered.

For many people, the mere mention of the woods during May brings to mind a carpet of bluebells.
Just as the buds are opening on the trees to reveal a flush of green, these familiar flowers burst into bloom. They time their arrival precisely; as late as possible but while light is still able to penetrate to the woodland floor. However, it is important that bluebell plants are shaded from the direct rays of the summer sun. Whilst some woodland plants increase in numbers when a coppice has been cut and the canopy thinned, it causes a decline on bluebells.

Among the bluebells many other woodland plants thrive, such as ramsons, wood spurge, dogs mercury, wood anemone and early purple orchid.

6

A bluebell wood in full flower is possibly one of the most spectacular natural scenes of the British Isles.

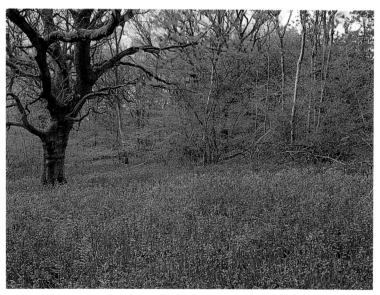

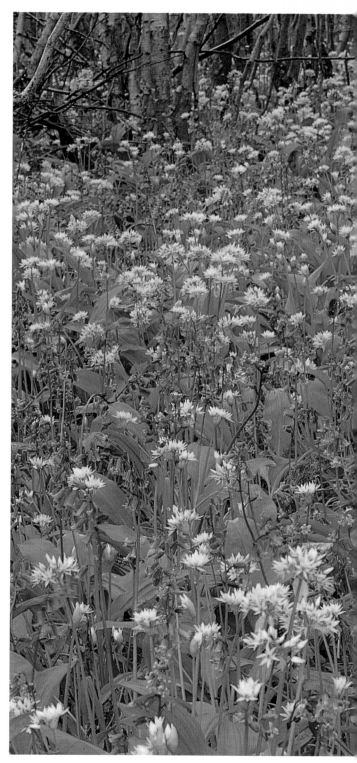

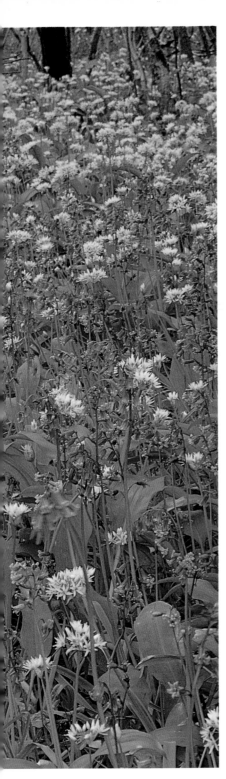

Not all plants of the woods grow in vast numbers — some species are much more individual. Although early purple orchids are not uncommon they are only discovered in small, loose groups. They enjoy a similar habitat to the bluebells and flower at the same time of year, so it is not uncommon to find an early purple orchid hidden among the bells.

A mixture of ramsons (often called wild garlic) and bluebells, in equal proportions, is hidden deep within an ancient piece of hazel coppice.

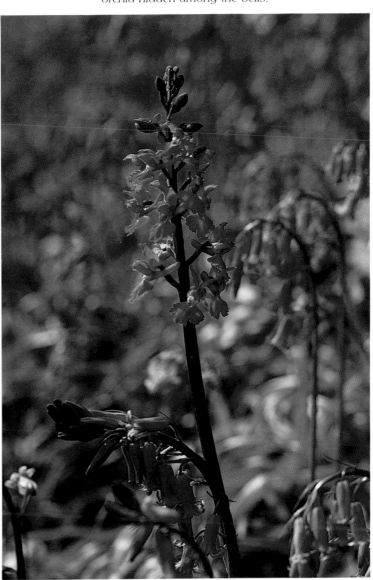

Two birds that are strongly associated with woodland are the jay and green woodpecker. Due to a fondness for ants, green woodpeckers are more often tempted from the woods than other woodpeckers. They can often be discovered on lawns, golf courses and fields that are a long way from trees. The green woodpecker breaks into an ants' nest using its powerful beak, then with its tongue it probes into the holes and passages of the ants' nest. The woodpecker's tongue is wonderfully designed — not only is it extremely long, it is also barbed and coated with sticky saliva.

Jays have a varied diet, but during the autumn they are constantly searching for acorns. Having eaten a few, they bury many more for consumption during the hard winter months. The jay's memory is very good and it will find most of its hidden supply, but not all. Acorns that are left buried beneath the ground germinate and new oak trees begin to grow in places they could never have reached without the help of a jay. It is claimed that the jay is responsible for the distribution of the oak woods throughout Europe.

8

Jays will eat a great variety of food and are certainly not adverse to taking young chicks from nests. Attracted to the calls of green woodpecker chicks, a jay investigates the woodpecker's nest but the entrance is too small for it to gain access to the helpless young.

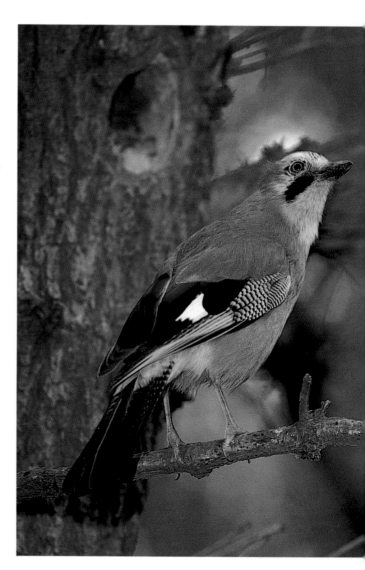

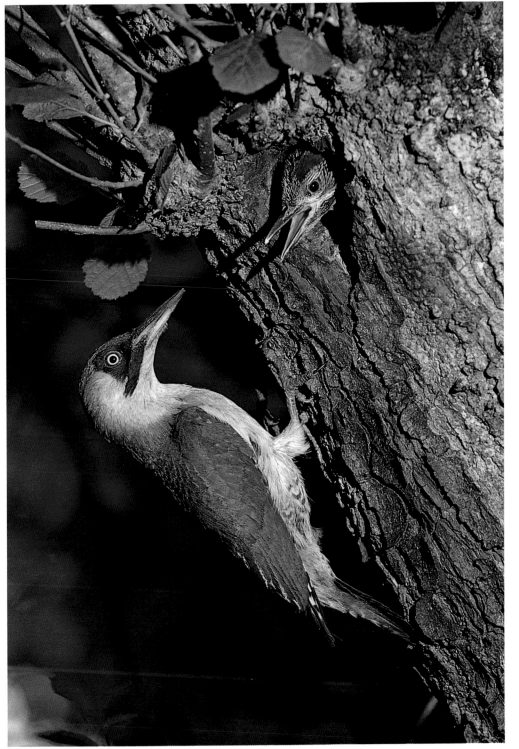

The amount of effort required for a green woodpecker to construct its nest is quite remarkable. The cavity has to be large enough to house five to seven young, plus an adult. To make the task a little easier it selects a tree that is rotting inside, even though the outside seems healthy. The pile of wood chips at the base of the tree gives an indication of the size of the cavity. The effort is worthwhile because it provides a secure place in which to raise their chicks.

Although bluebells flower in Europe, it is only in the British Isles that they are found in such profusion. The whole floor of the wood is a shimmering carpet of blue as each bell trembles in the breeze.

Bluebells are part of the hyacinth family, and so grow from bulbs. They do produce seeds but their main method of multiplication is through the white bulbs, hidden beneath the ground.

Early in the morning an unseasonal mist clings to the woods. It creates an atmosphere that is strange and shadowless.

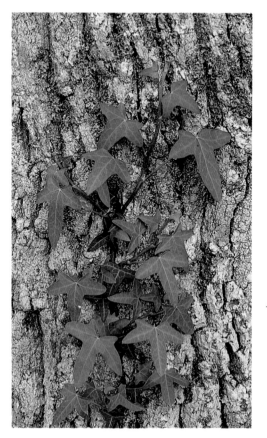

Ivy clings to the bark as it begins its long journey up a tree. At this climbing stage the leaves have either three or five distinctive lobes. Once it has reached high up the trunk it will send out fertile stems that produce the flowers. These stems have pointed, oval leaves.

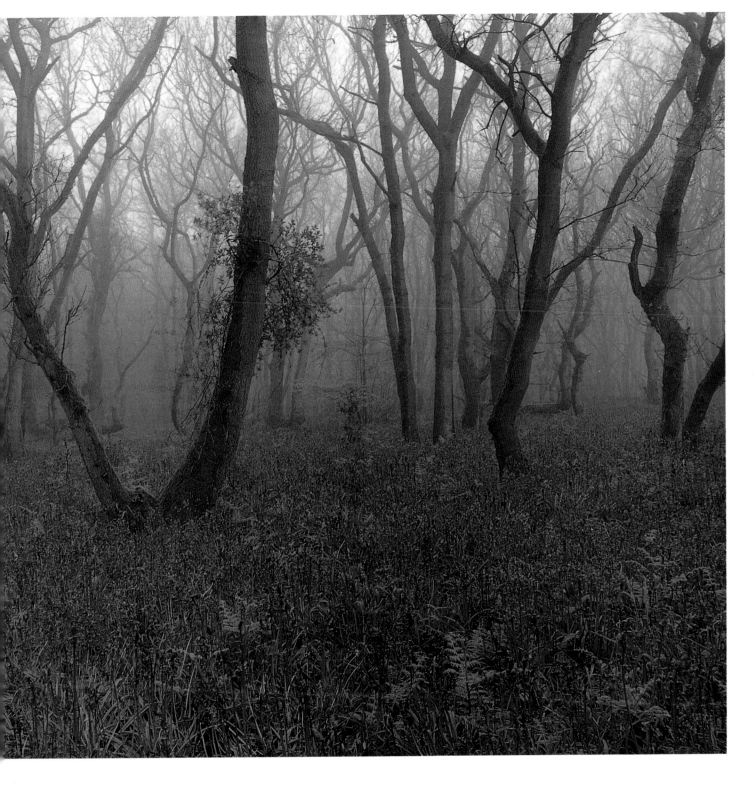

For many months the woodland floor has been covered in dead leaves, rotting twigs and fallen branches but with the arrival of spring a sudden flush of green carpets the ground. It must be a welcome relief for animals such as the muntjac deer to have fresh shoots to feed on. Deer are browsing animals — they prefer to eat roughage such as brambles, tree and shrub leaves, ivy and even twigs, but by the end of winter there is little left in the wood for them to eat. Muntjac deer are one of the few mammals that eat bluebells and dog's mercury. If given the opportunity they will creep into gardens to eat cultivated plants, especially roses, and some have been know to steal food from bird tables.

An unusual feature of the muntjac is that they breed throughout the year, which means that fawns may be discovered at any time. Only a few days after a fawn is born the doe comes into season, so that a female can be almost continuously pregnant.

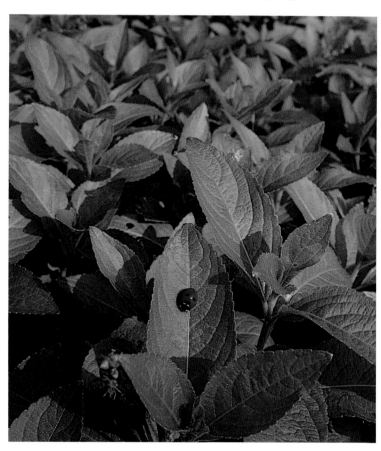

The fresh green of dog's mercury completely covers the woodland floor. Once spring activates the plants, insects such as seven-spot ladybirds come out of hibernation. They do not feed on the plants but search the vegetation for aphids and other tiny insects, which form their diet in both the larval and adult stages.

12

Muntjac deer are not native mammals but were introduced from China and Taiwan in about 1900 (they are sometimes referred to as Chinese muntjac). They escaped into the wild and seem at home not only in our woodland but also beside motorways and even in gardens. It is a very small deer, not much larger than a fox, and walks with with a distinctive hunched-back gait.

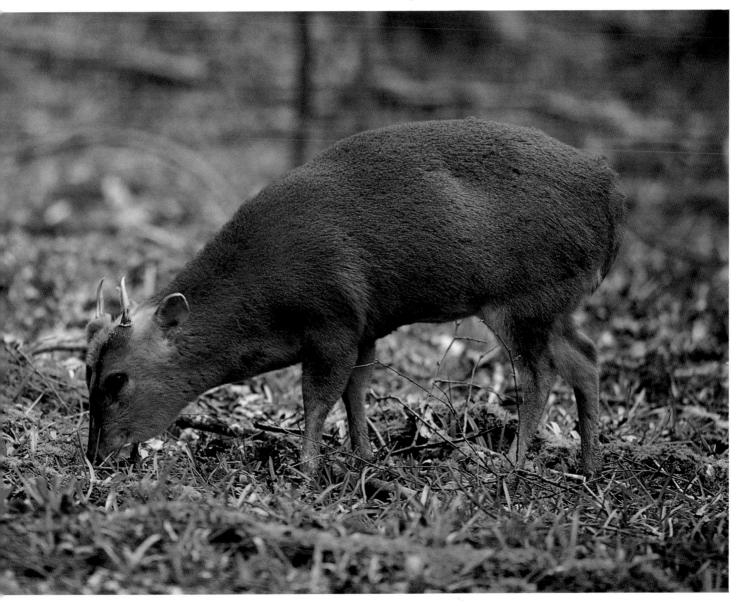

A walk through the woods seems incomplete without a view of a woodpecker. There are three species to be found in British woodland, the most widespread and numerous being the great spotted. Its diminutive relation, the lesser spotted, is the least common and due to its size and secretive nature is the most difficult to find.

Both of these species feed on the larvae of wood-boring beetles which they locate by listening for their movements. Using their powerful beaks they open a way into the grub's tunnel and, using their long barbed tongues, the tasty morsel is winkled out. Great spotted woodpeckers supplement their diet during the winter with nuts or seeds — they have discovered garden bird tables where they feed readily on peanuts and suet.

Drumming is a characteristic of woodpeckers during the nesting season. A bird selects a favourite branch that has a particular resonant quality and with rapid blows of its beak, it sends its drumming call through the woods to advertize for prospective mates. The woodpeckers have specially designed and cushioned skulls that enable them to strike the solid wood without knocking themselves unconscious.

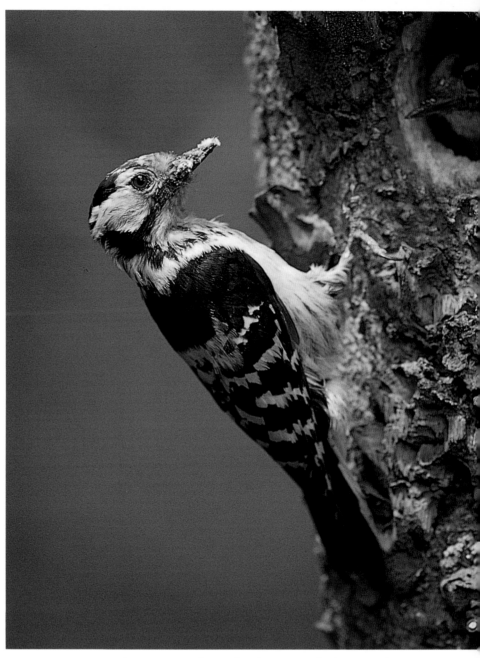

Lesser spotted woodpeckers are only the size of sparrows, so it is easy to tell which species created a nest hole. The diameter of a lesser is only 3.2 cm, whilst a great spotted measures 4.6 cm. The sexes can be distinguished by the male's red crown or cap, and the female's white.

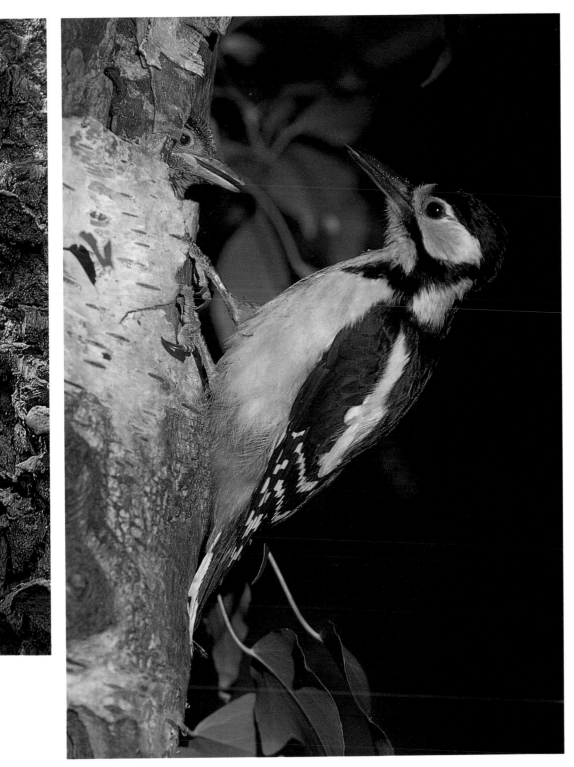

The chicks of great spotted woodpecker remain in the nest for about three weeks, until they are fully grown. Five or six is an average brood and so the adults are kept busy bringing a constant supply of insect larvae to the nest. During the last week the young birds learn to climb up the inside of the nest and call noisily out of the hole, encouraging the parents to return with more food.

The habitat of the woods is a mixture of light and shade. Subtle patterns of light flicker through the canopy to highlight the plants below from every angle.

Details of the translucent leaves are highlighted when back-lit by the sun, adding beauty to the atmosphere of the wood.

Speckled woods are typical woodland butterflies, their dappled brown and cream markings merging with the vegetation. Seen from below it casts a shadow silhouette onto the hazel leaf on which it is resting.

16

The flowers of the wood spurge are most unusual because they have neither petals or sepals. Instead, the reproductive parts are contained in a cup-like structure below which bracts (similar to leaves) resemble green petals.

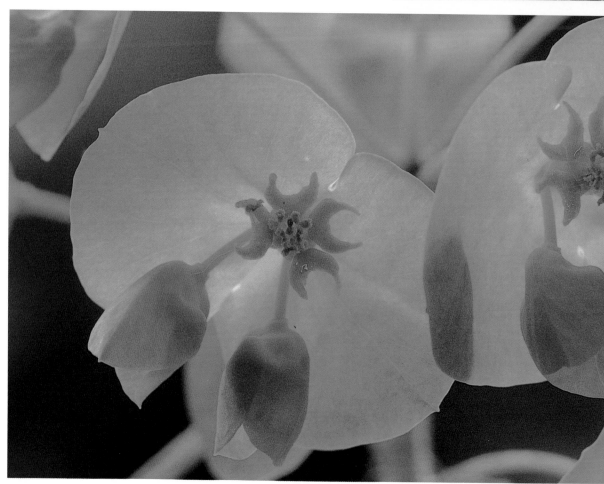

Dog's mercury can survive in very shaded conditions and often covers the woodland floor. It flowers very early in the year and the male and female flowers appear on different plants.

The icy blast of winter sweeps the final autumn leaves off the trees, leaving the wood stripped and naked waiting for the arrival of the following spring.

Hanging like giant creepers in a tropical rain forest, traveller's joy waits for spring to arrive. The thick, woody stems have little strength of their own and rely on the support of other plants as they relentlessly head for the canopy and light.

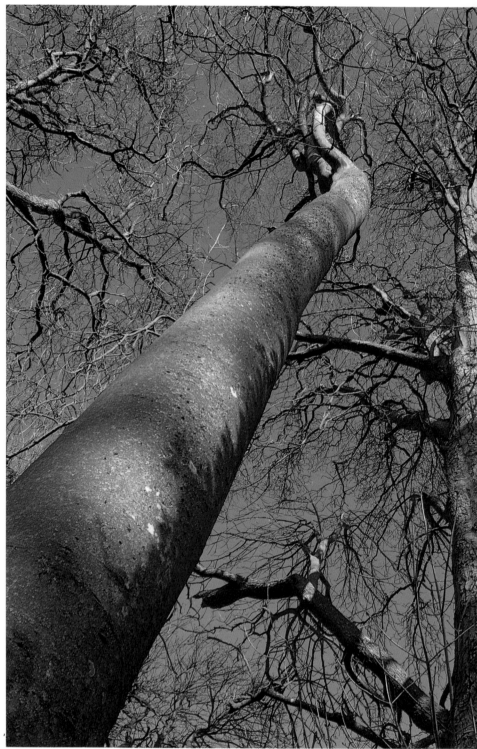

Mighty trees reach up towards the blue sky — they are virtually dormant until the spring.

Suspended in the bare twigs of a silver birch tree, a spider's web is decorated with drops of water from the constant drizzle.

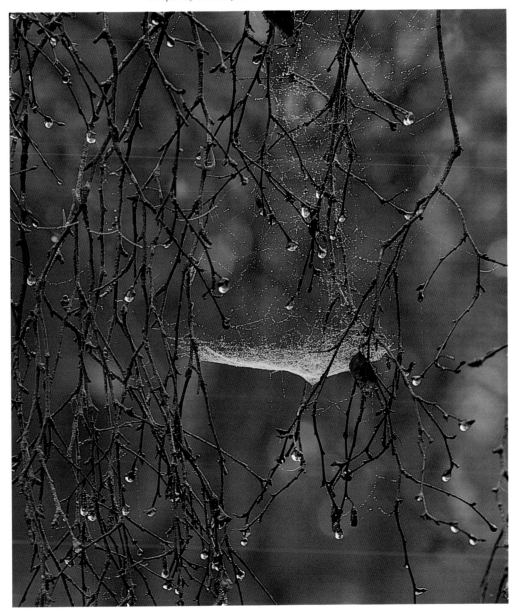

Winter in Britain means frost, snow and ice. In fact only a small proportion of winter in the British Isles is decorated with these remarkable phenomenon that we take so much for granted. That every leaf, twig and blade of grass could be so transformed by something as simple as freezing water is yet another miracle of the natural world.

Bramble leaves seem more able to withstand a hard frost than many other plants. As a result this species has a long growing season which may account for its tenacity and abundance.

Fallen oak leaves have served their useful purpose and now lie decomposing into life-giving nutrients. For just a few hours the frost restores something of their former beauty.

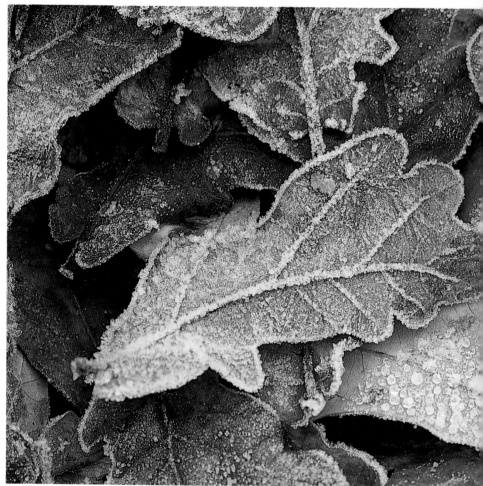

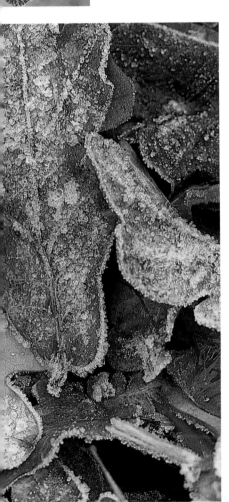

Withered grasses lie dead on the ground,
but with a coating of frost their curling
blades create a natural abstract pattern.

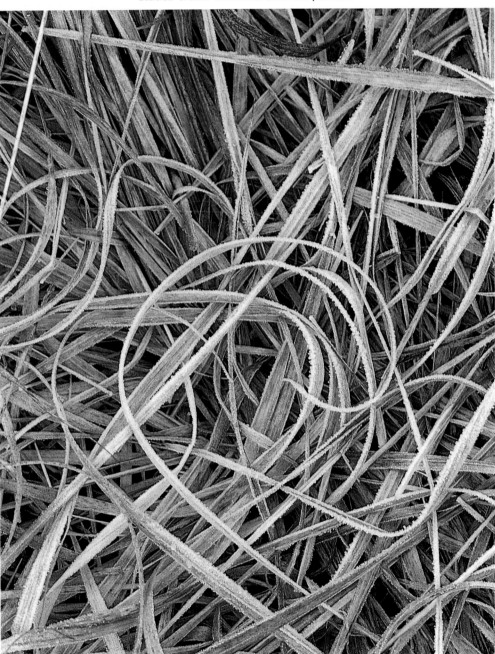

Comparatively few creatures enjoy the environment of a conifer plantation. In general they support too few insects for birds to feed on and the heavy shade defeats any attempts of natural plants to become established. However, there are a few opportunities for wildlife to encroach into what we must think of as a man-made habitat.

Nightjars make use of areas where the timber has been felled and replanting taken place. For several years the trees are small and the rough ground in between makes suitable nest locations.

Unlike most deer, sika are grazing, rather than browsing, animals. They do not need to feed in the wood. During the daylight they make use of the thick cover of the plantation and come out in the evening to feed in the nearby fields.

Nightjars lay their eggs on the ground in the simplest scrape and rely on their camouflage to such an extent that one can pass within a couple of metres without them flying off. In the photograph a hen and her chick are sitting together.

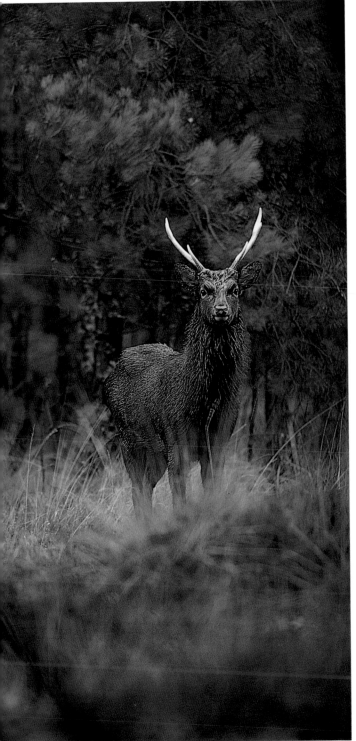

During September and October, the season of the rut, sika stags look most splendid. They have glossy dark coats, shaggy manes and antlers that are almost white. Having rounded up a harem of hinds they attempt to defend their rights against all-comers.

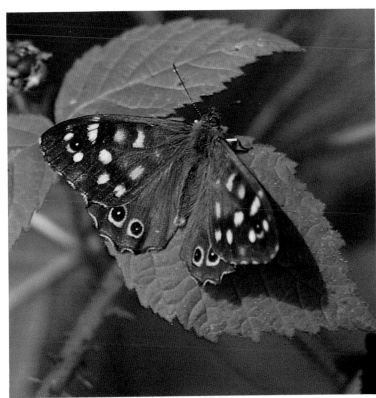

Brambles thrive in the woodland rides and speckled wood butterflies feed on their flowers. Being territorial butterflies they can often be seen chasing each other as they defend their own 'patch'.

By mid-summer the plants beneath the canopy have completed their flowering process. But in clearings, where sunlight penetrates, other plants continue to flower. These are mainly plants which have deeper root systems and are able to reach moisture when the surface has dried out.

As a result of the flowers, the woodland seems to hum with life. Bees, flies, and hover-flies all contribute to the sound effects of the wood as they gather nectar or pollen. Without flowers many insects could not exist but on the other hand, without insects neither would flowers exist. Everything in the wood is designed to fit into place, and nothing can exist on its own.

The first plant many people learn to identify as small children is the stinging nettle. Although they are not popular and we never stop to study or admire them, we rarely fail to notice them. What an incredible defence mechanism!

24

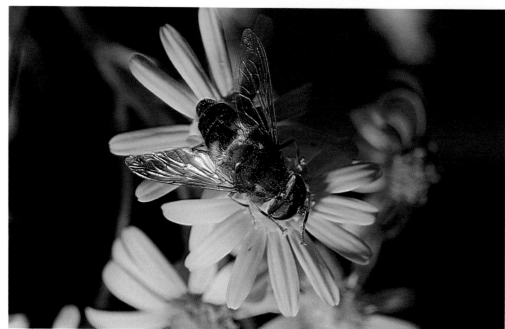

There are over two hundred different species of hover-flies in Britain, and a large number are found in woods. Many have striking colours and markings which are designed to mimic bees and wasps. This enables them to feed out in the open on flowers, and birds avoid them in the same way as they do stinging insects.

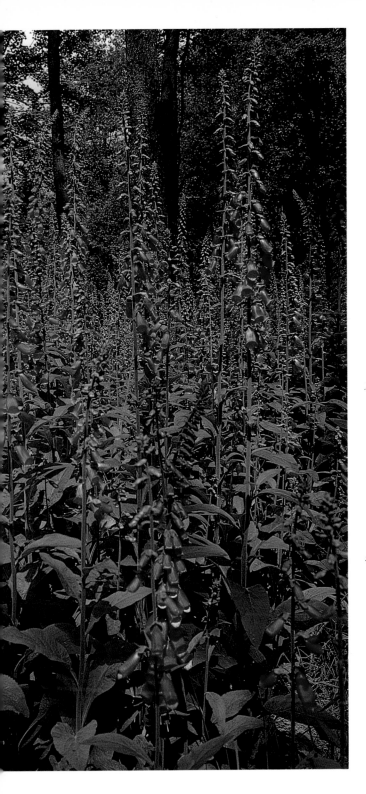

Rosebay willow herb is sometimes called fireweed because it is often the first plant to become established after a fire. It is certainly not limited to woodland and can be found growing in many waste places. It produces a mass of fluffy seeds that carry long distances in the wind, and so it is often thought of as a fast-spreading weed.

Foxgloves must be one of the most popular plants found in the woods and hedges — so popular that it is often cultivated in the garden. Yet all parts of the foxglove are extremely poisonous, especially the seeds. But who can deny that foxgloves create a wonderful splash of colour to many woodland walks?

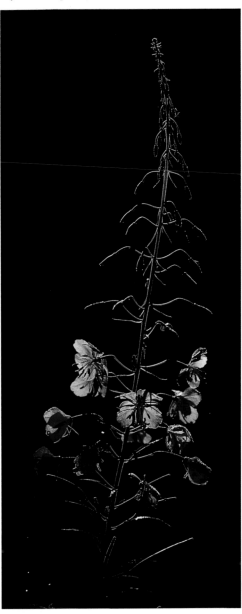

Snow. You either love it or hate it, but certainly can't ignore it. Even those who dislike snow cannot help marvelling at the beautiful transformation that an overnight fall brings to the woodland. However, it does interfere with our routine, and quite often things come to stand-still.

In nature things cannot stop, because to stop means to die. The activity in the woods can be seen by the network of footprints in the snow; deer, fox, rabbit and even badger. Looking closer we can find that voles and mice are as active as ever, while footprints of birds map out their movements, even though they are difficult to identify. Nevertheless, a deep blanket of snow creates problems for many creatures trying to find food.

26

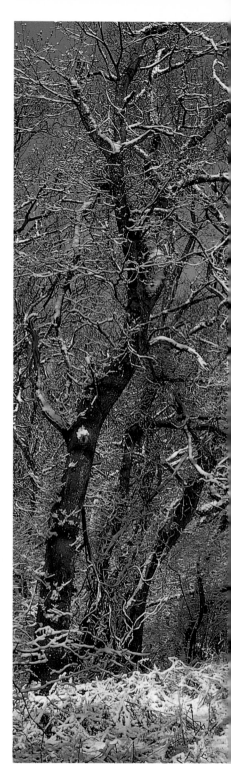

Although the weight of snow may occasionally break branches from conifer trees, it acts as a protective insulation from frost and in general plants benefit from the fall.

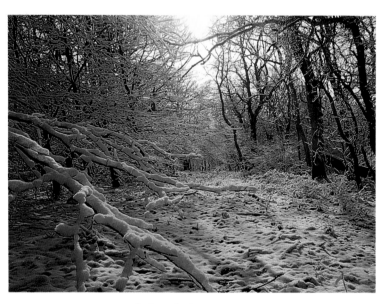

A drop in temperature of only a few degrees transforms the wood from a muddy, rain-soaked wilderness into a picture postcard fairyland.

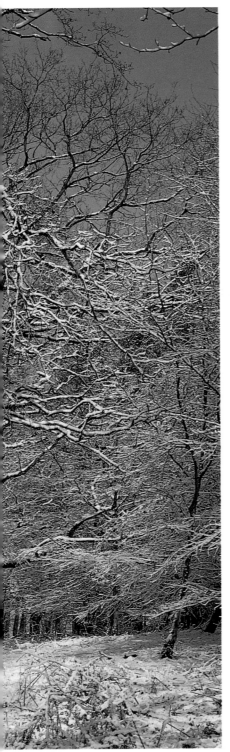

Few of us would look twice at bare
winter twigs, but a coating of snow creates
a monochrome abstract pattern.

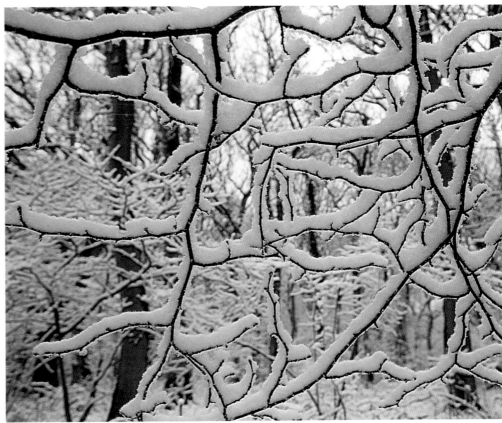

As the canopy develops during the spring the woodland becomes increasingly shaded. The effect of dappled light filtering through the canopy is to highlight some things, while others appear to blend into the background. Some creatures of the wood use the effects of lighting to make them stand out — courting butterflies for example. However, a fallow deer has a dappled coat so that it can use the same effect for camouflage.

28

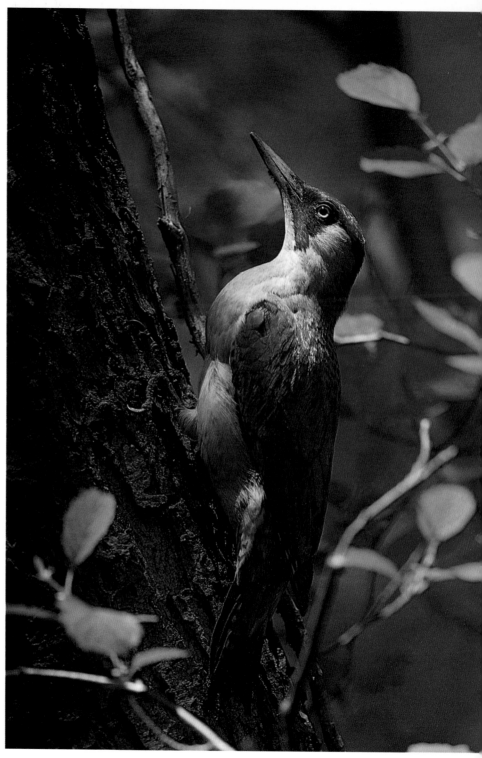

That such a large and colourful bird as a green woodpecker can be so difficult to find is a mystery. However, it is a mystery that can be solved by observing the effect of dappled lighting.

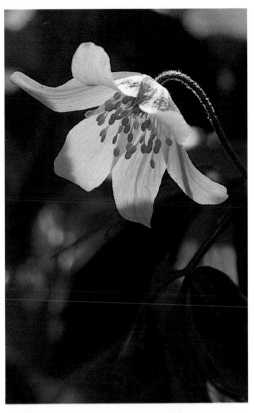

A wood anemone is highlighted by a shaft of sunlight. It opens quickly in response to the sun, but closes equally rapidly as the light fades.

Dappled sunshine falls onto spent beech masts that litter the woodland floor.

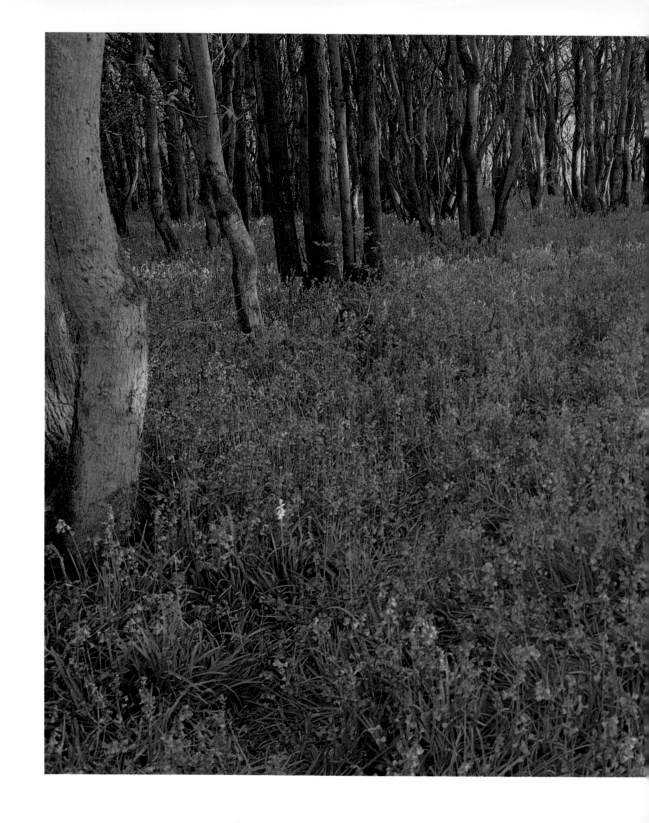

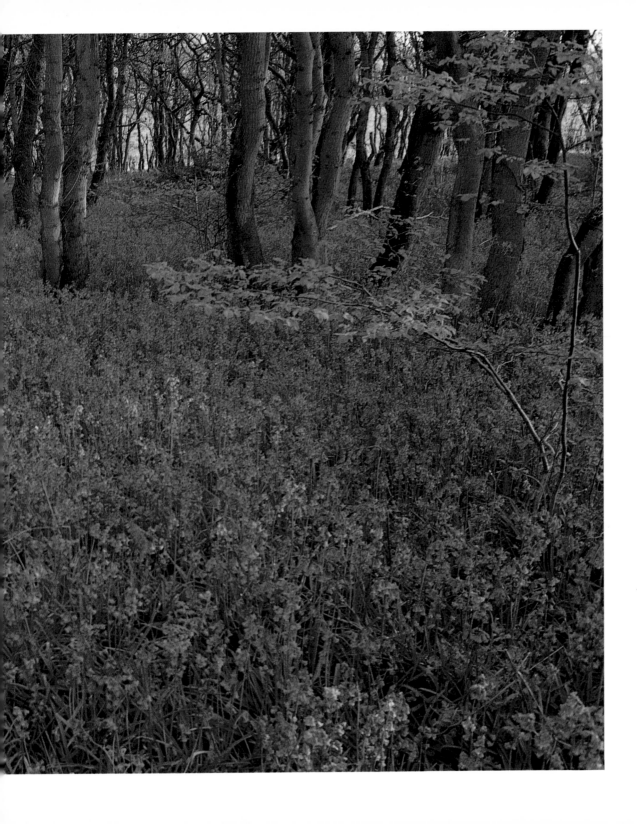

Fungi are active throughout the year, but it is only when they produce their fruiting bodies in the autumn that they are noticeable. In fact, a fungus is really a mass of tiny threads know as hyphae which are as slender as hairs and grow through the food source like roots. They form a dense network of microscopic filaments called mycelium and draw nutrients directly from plants which may be either alive or dead. Some species live on rotting animal matter or dung.

When climatic conditions are right, two mycelia of the same species come together and a fruiting body may be produced. The autumn months often produce the perfect conditions of temperature, humidity and so on, and so many fungi produce their fruiting bodies at this time of year.

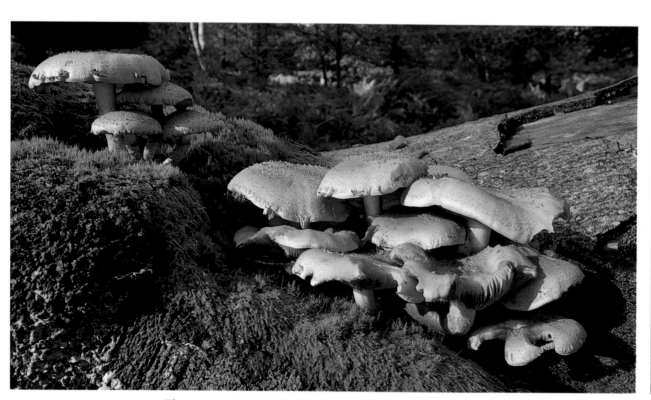

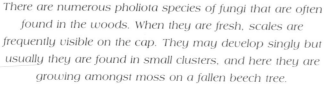

There are numerous pholiota species of fungi that are often found in the woods. When they are fresh, scales are frequently visible on the cap. They may develop singly but usually they are found in small clusters, and here they are growing amongst moss on a fallen beech tree.

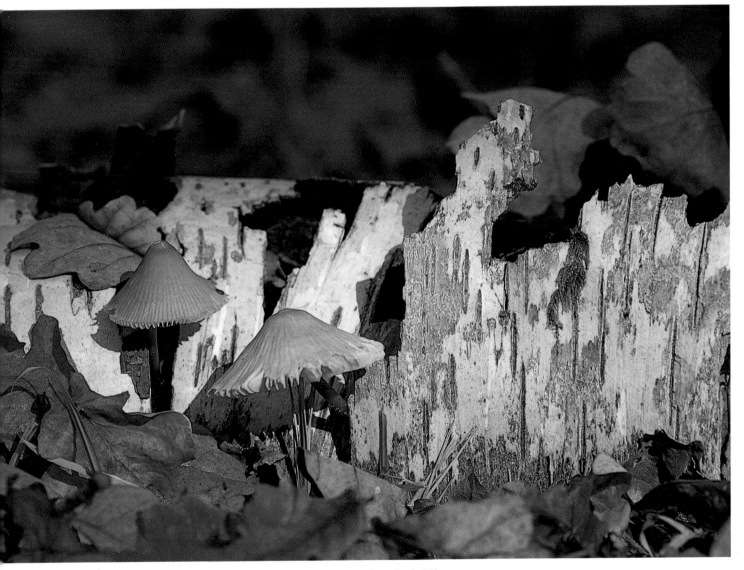

In the British Isles there are over a hundred different species of fungi in the genus Mycena. They are small and delicate and are supported on long fragile stems. Because of their size they are often overlooked on a walk through the woods.

Many wild plants can be identified by their flowers, because of their variety of colour, shape and size. Every year a great harvest of berries appears towards the end of summer and during the autumn. The ripening berries are just as distinctive as the flowers from which they have developed, each species having their own features. Even if they are the same colour, they are still easily identified because of their arrangement on the stems.

The bright red, shiny berries are designed to attract birds which eat them whole, digesting the soft outer flesh and passing the hard seed. It is an effective method of seed dispersal and ensures that each seed has a good start because it is delivered with a convenient package of fertiliser!

34

The twisted stems of black bryony look lifeless, but its bright berries carry the seeds of new life.

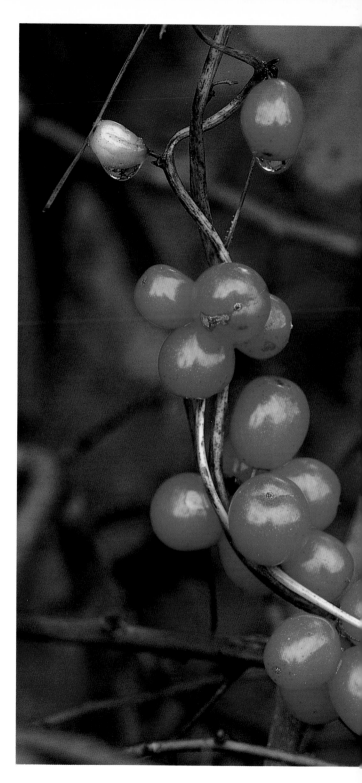

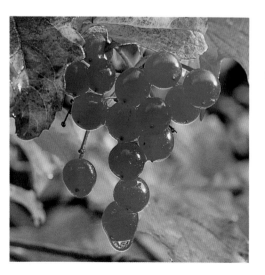

The berries of the guelder rose are bright, shiny and translucent and they hang on the shrub well into November.

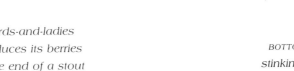

Lords-and-ladies
produces its berries
at the end of a stout
stem only 20-30 cm
high.

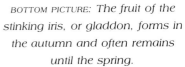

A spindly twig supports a cluster
of honeysuckle berries well above
ground level.

BOTTOM PICTURE: The fruit of the
stinking iris, or gladdon, forms in
the autumn and often remains
until the spring.

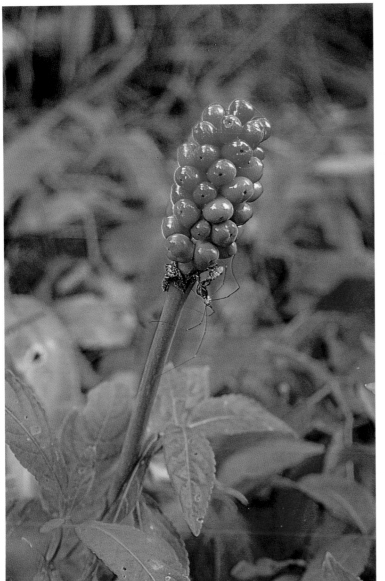

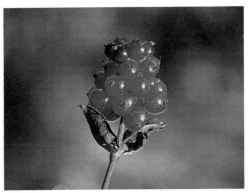

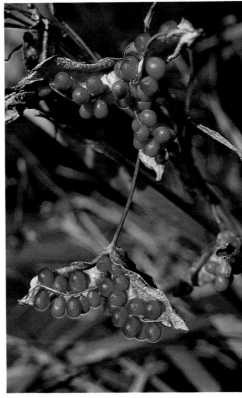

In autumn the trees of the woodland produce seeds to establish the next generation. Comparatively few of them will ever have the opportunity to germinate because many creatures of the woods regard them as a true feast. They are very portable and storable packages of food and so mice, squirrels, magpies and jays are busy creating secret stores for winter use. They are also high in carbohydrates which enable other animals such as deer to put on body reserves ready for the approaching winter months.

36

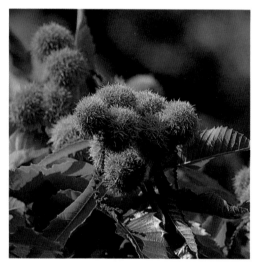

Being so palatable, sweet chestnuts are very popular with squirrels which seem to have no problem dealing with the prickly jacket that surrounds the nuts.

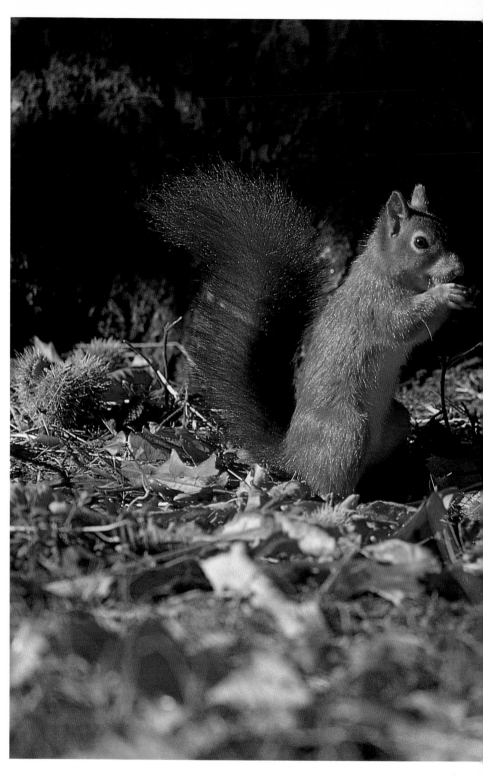

The red squirrel is a natural British species, and is a pretty and delicate little animal. In general it spends more time hidden in the tree canopy than the grey squirrel and proportionally less time on the ground, although it cannot resist searching for the fallen sweet chestnuts.

Colours of autumn begin to tint every tree in the woods.

The life and death struggle continues both day and night with a variety of predators hunting small mammals and song birds. Within the natural world death usually strikes quickly and unexpectedly. The odds are in favour of the prey and it is only when they are taken by surprise that the predator has any hope of success. As a result, long drawn out fights or chases are rarely seen in the woods.

Birds, such as the sparrowhawk, rely upon speed, whilst the owls use their silent flight. In both cases the prey is unaware of their doom until the last second.

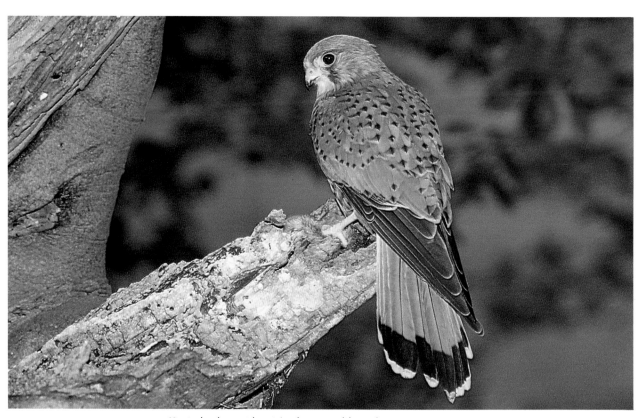

Kestrels do not hunt in the wood but choose more open country where they can hover whilst watching the ground for small mammals. However, they will make use of a hollow tree to raise their chicks.

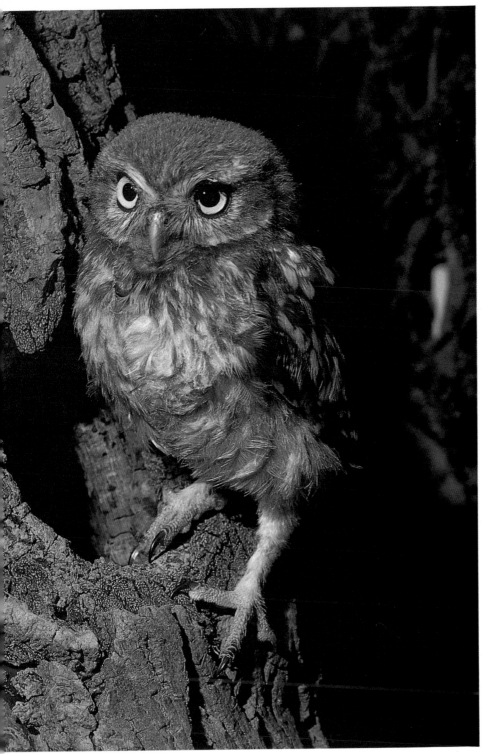

Little owls usually nest in hollow trees which can often take them into the wood. They tend to hunt in more open country in the twilight of dusk or early morning. Although they take small mammals and even roosting birds, a high proportion of their diet is made up of insects and worms.

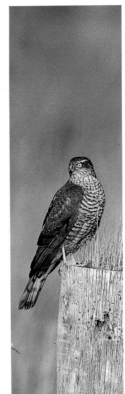

Flying at high speed along a woodland ride or hedge, a sparrowhawk makes use of trees as cover to catch its prey off guard. They often take over old crows' nests or squirrels' dreys as a nest location.

In mid-summer, woodland glades and rides buzz with the sound of countless insect wings and fragile butterflies flit from flower to flower. Many species of butterflies are strongly associated with woodland whilst others may simply enjoy a passing visit to feed from the plentiful supply of wild flowers.

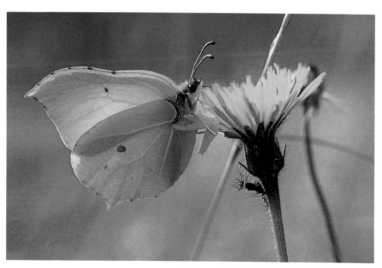

The brimstone is one of the first butterflies to appear in the spring. The pale yellow males can often be seen as early as March.

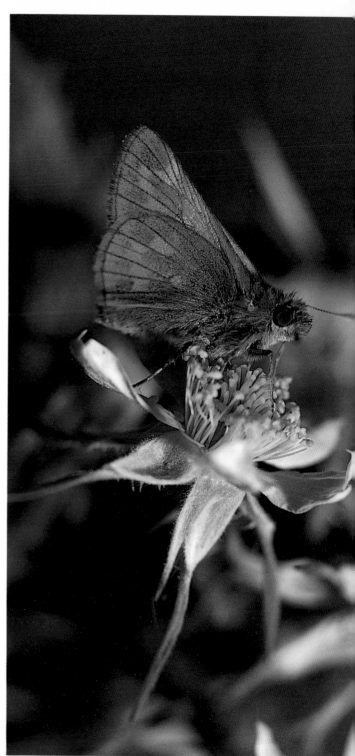

Typically, the large skipper has a strong and rapid flight and when it settles it often holds its forewings raised at an angle.

Small coppers are common butterflies, although they are rarely seen in large numbers; here it is feeding on fleabane.

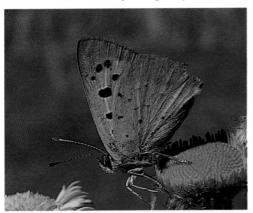

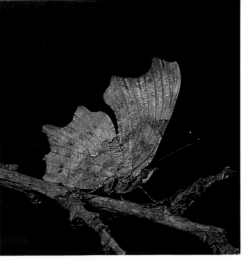

Once the comma butterfly closes its wings it is wonderfully well camouflaged. It so closely resembles a dead leaf that it is easily overlooked, even when settled on a bare twig.

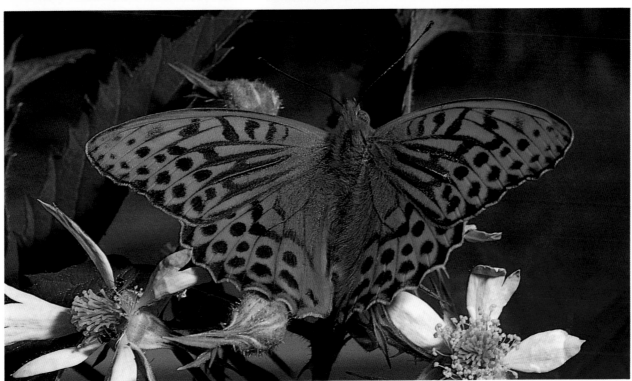

The silver-washed fritillary is primarily a butterfly of southern woods. This is because the larval stage feeds upon dog violet, a woodland plant.

Using its powerful feet and long claws, the nuthatch is able to move with quick jerky hops up, down or sideways around a tree with equal ease. Even apparently impossible overhangs are negotiated without the bird having to resort to flight.

Its choice of nest location is in a natural cavity and it uses mud to fill in any cracks or holes and then fills in the entrance until it is exactly the right size for its body to pass through. This prevents larger birds or mammals gaining easy access to its eggs or young.

Nuthatches search the trees for insects during the summer but in the autumn their diet changes as they eat more nuts, acorns, and so on. They are regular visitors to birdtables, where they take peanuts.

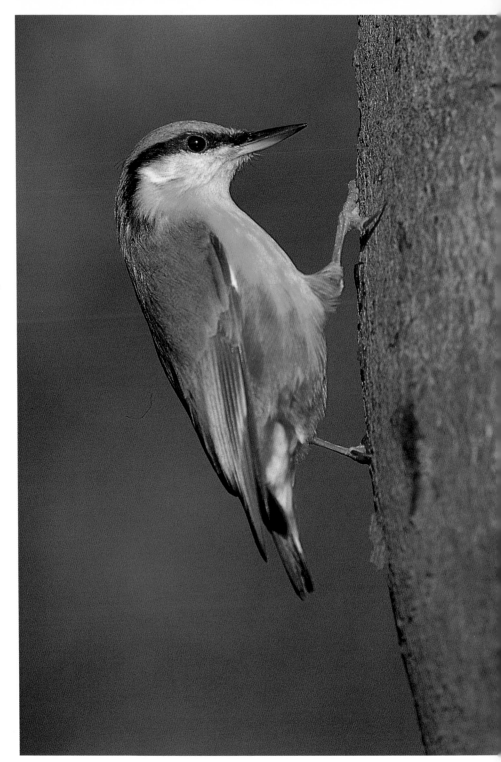

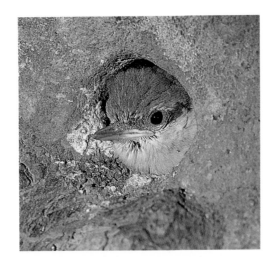

A young nuthatch looks out of the mud-lined entrance waiting for its parents to return with food.

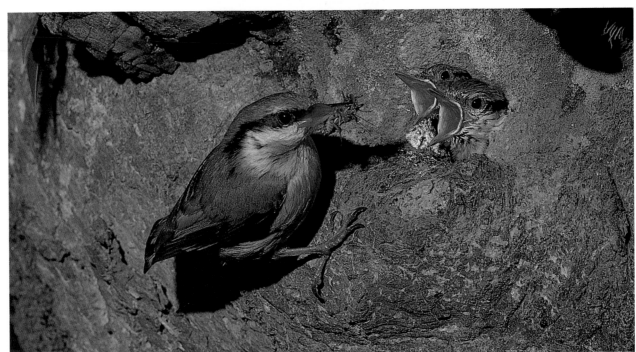

The opening into the nest cavity was about six centimetres in diameter until the birds reduced it to their body size by using mud. Nevertheless two chicks still manage to squeeze their heads out of the hole as they beg for food.

There are a huge number of species of fungi to be discovered in the woods, and whilst some are very distinctive others are difficult to tell apart. The fruiting bodies of fungi go through a variety of different stages. Sometimes this may take only a few hours but with other species it could be many weeks. This adds to the problem of precise identification even to those people who specialize in fungi.

Fungi live on a variety of substrates and many feed on rotting, dead or dying wood. They play an important role in breaking down fallen branches and trees, eventually enabling the nutrients to be returned to the soil.

44

Many different types of fungi can be found even on a short woodland walk, especially during the autumn.

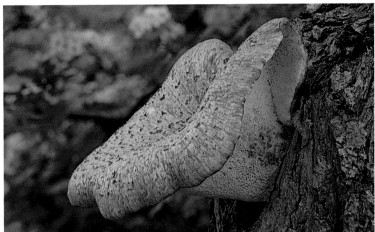

Although many species of fungi in the polypore group feed on dead wood, this particular species is a parasite on a living tree. Close examination of the under-side and stem reveals pores from which spores are released.

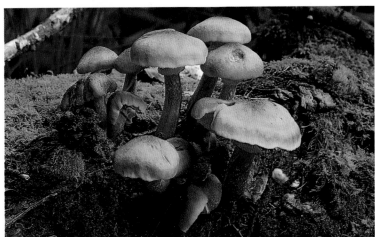

The honey fungus is a very common species found on most walks through the woods. It can be variable in its appearance, usually being in large clusters around dead stumps or the trunk of a living tree.

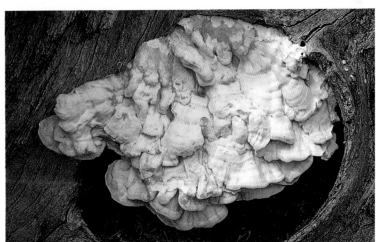

The sulphur polypore gained its common name from its sulphur yellow colour when fresh. It is also referred to as 'chicken of the woods' and is considered a delicacy in other countries.

Within the natural world there is a constant life and death struggle. The 'food chain' — where the plants are at the lower end and predators are at the top — is part of the web of life. At first it would seem that life is easiest for the predators such as foxes or buzzards but this is not necessarily the true picture. Any upset in the balance lower down the chain can often be exaggerated the further up you look.

Extremely few seedling trees ever survive to maturity due to competition from other trees and grazing from mammals. A high percentage of eggs laid by song birds never hatch due to egg thieves in the form of magpies, squirrels and so on. Moths lay eggs and birds eat the caterpillars, blue tits fledge their young and they are caught by a sparrowhawk, and plants burst through the soil in spring to be eaten by rabbits which, in their turn, are taken by buzzards.

Life in the woods is a struggle.

46

Soaring high above the canopy, a buzzard sees the woodland very different from a ground-living mammal. Although buzzards use the wood as nest sites and secure roosts, they usually hunt in more open country.

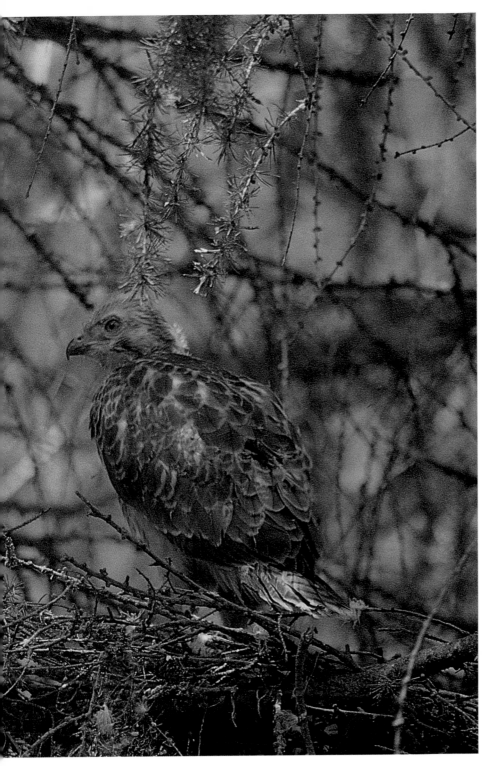

Even though buzzards are at the top of the food chain only one youngster was raised in this nest. Two or three are more usual but perhaps food was in short supply or bad weather conditions made hunting difficult.

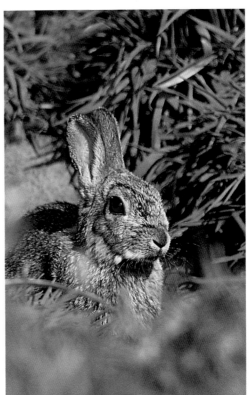

Rabbits seem to be on the menu for a large number of predators, but the rabbit has good sight, hearing and smell, and a turn of speed that gives most predators a run for their money.

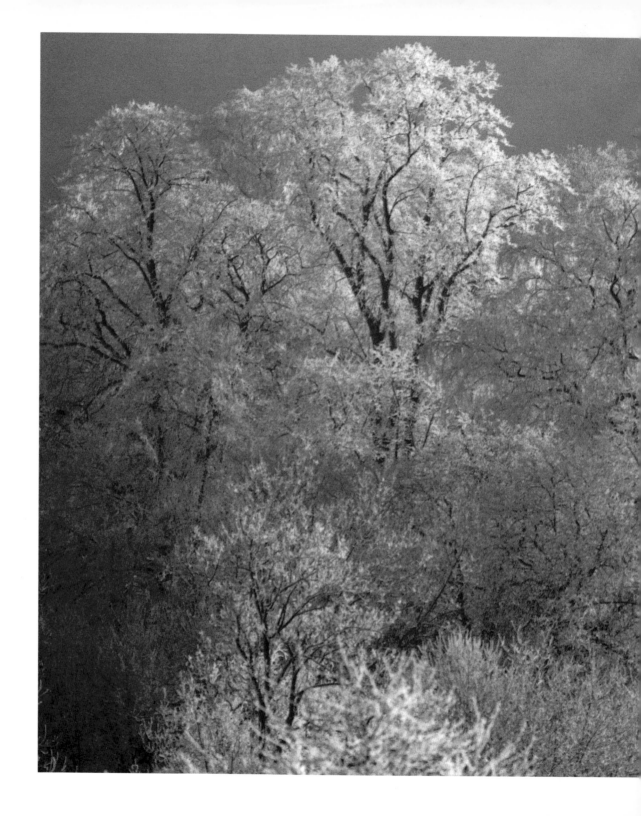

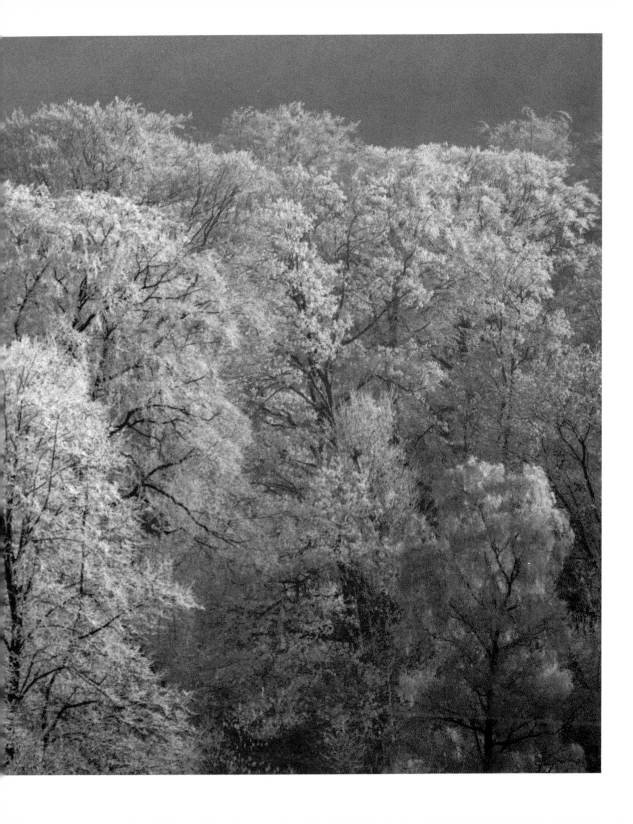

It is not often that the woodland is decorated to such an extent by frost and its appearance is only short lived. As the sun rose in the sky the frost melted; it did not drip from the trees but fell to the ground in showers of ice crystals, tinkling like tiny bells.

Walking through the frosted woodland with the ground crunching beneath your feet, it is difficult to imagine that the stark trees will bear fresh green leaves in only a few months.

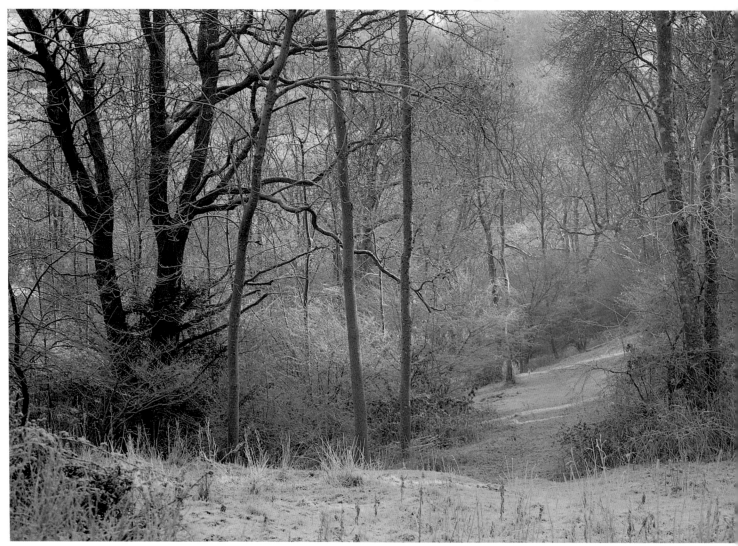

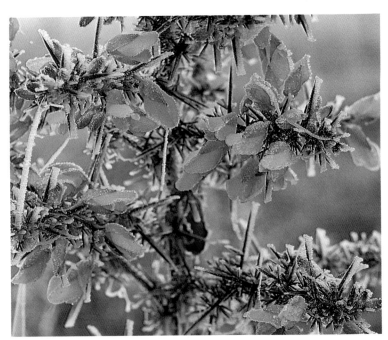

It is said that gorse can be found in flower almost every month of the year. Even on a winter's day, a cheerful splash of yellow may catch the eye

Every twig and stem is decorated with ice. The contrast between the dark twigs and sparkling white frost creates a wonderful natural mosaic.

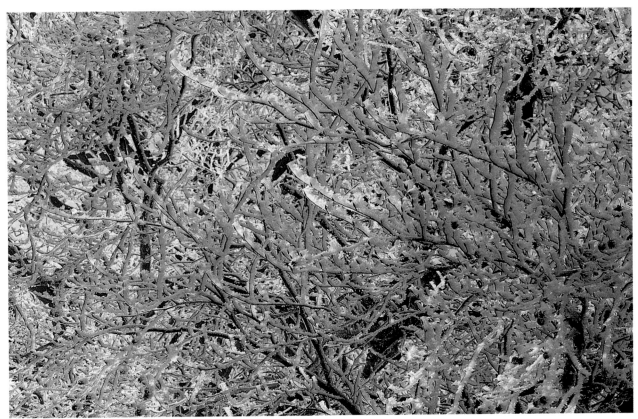

Deer hold a fascination for many people, perhaps because they are the largest of the woodland mammals. Whatever the reason, a walk through the woods is enhanced by the sight of one of these splendid animals.

The roe deer is the smallest of the native species, tending to be shy and secretive. They feed mainly during the twilight hours of dawn and dusk and enjoy browsing the woodland trees and shrubs, as they prefer twigs and coarse leaves to more succulent grasses. Towards the end of winter, when vegetation in the woods is difficult to find, roe deer often change their habits and have to be content to graze in nearby fields.

Fallow deer are much larger and are an introduced species that are often found in deer parks. As a result they have become accustomed to humans and will tolerate a closer approach. Over the years they have escaped from parks to establish wild herds that roam the countryside, using the cover of woodland by day and grazing in the quiet of evening and early morning.

52

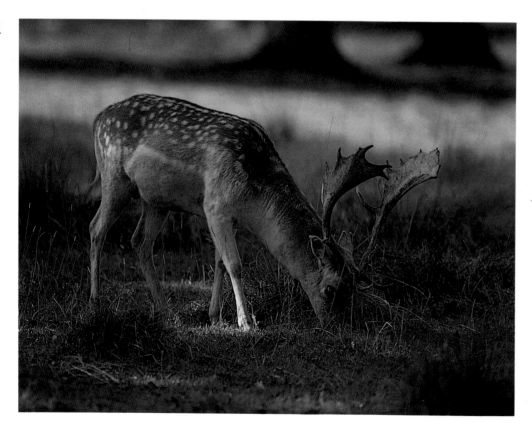

A fallow buck displays a splendid head of antlers from August until the following March. Then the antlers fall off and it has only five months to grow another pair ready for the next rutting season.

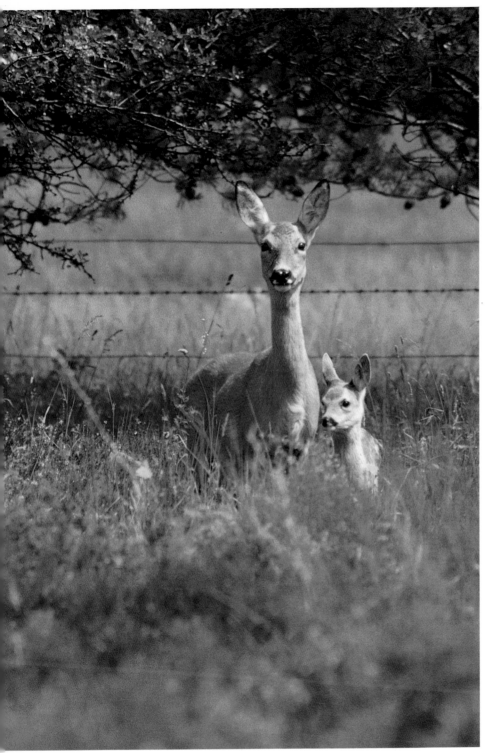

When the doe has a fawn at her side she tends to be even more secretive. Roe deer usually have twins and most of the time they are left hidden in tall vegetation and the doe only visits to feed them.

Roe deer tend to be more solitary than other species of deer, although they do form small loose herds in the winter months.

As the hours of darkness draw a veil over the wood a new set of players takes the stage Birds of the day are replaced by mammals of the night. In many situations the mammals are as abundant as the birds but for most of the time we are unaware of the existence of mice, shrews, voles and bats.

Bird-song no longer fills the air as a brown long-eared bat creeps out of its daytime roost. Typically it will fly slowly over the canopy producing soft ultrasound pulses, its huge ears enabling it to distinguish between a leaf and a living insect.

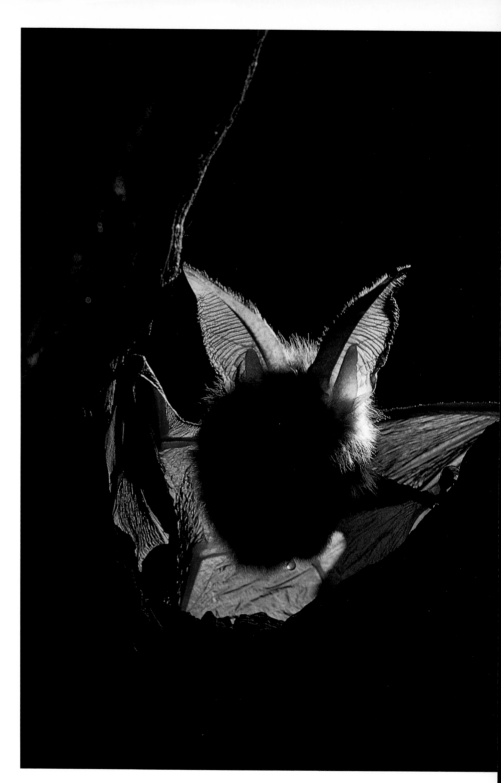

Bank voles eat a wide range range of vegetable foods, which include seeds, nuts, leaves, fruit, fungi, flowers, roots and even an occasional insect. They live in underground nests and often collect little stores of food in hidden chambers, for use during winter.

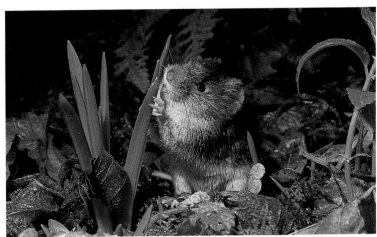

A hedgehog seems safe enough with its coat of spines to be able to roam freely during the day. Probably it has taken to its nocturnal lifestyle because its food of earthworms, slugs, earwigs, spiders and so on is easier to track down at night.

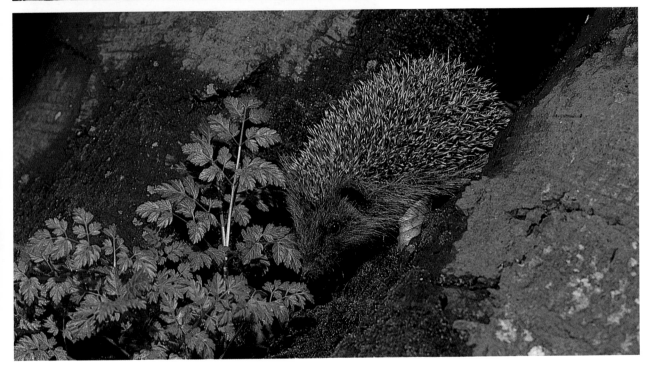

As the months of the year slip by, the woodland floor gradually changes. In mid-winter the ground is littered with leaf debris and fallen twigs, and then green spears, the shoots of snowdrops, bluebells or dog's mercury, break through the soil. At first just one or two appear, then little clusters here than there, then suddenly the whole floor is covered. Even the flowers have a natural progression through the months as one species replaces another.

May: ramsons, or wild garlic, are at their best, making a mottled white carpet.

56

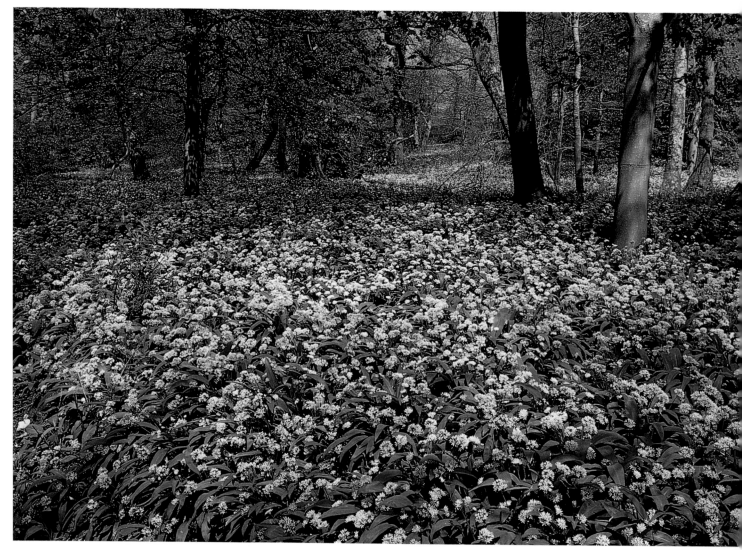

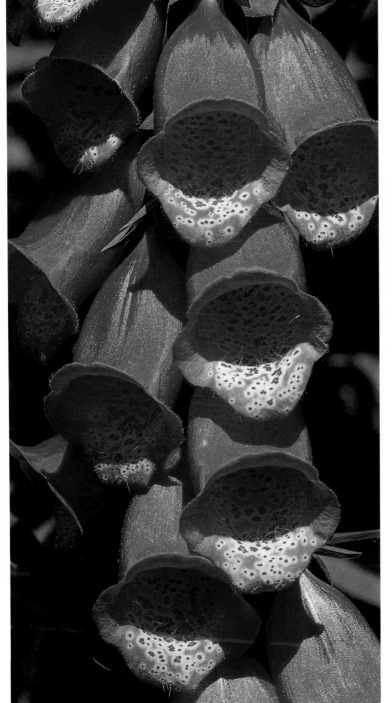

July: foxgloves
stand tall in
woodland glades
and rides, providing
colour in mid-
summer.

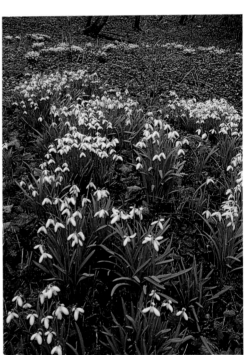

February: snowdrops dominate
this woodland floor.

Not everything in the natural world is attractive, and unappealing subjects are often ignored or overlooked. Some people dislike creatures such as spiders, snakes or centipedes, because of their appearance. But these parts of creation are just as interesting as the more brightly coloured or attractive creatures, and they are also very important.

We cannot separate birds from the insects upon which they feed, and we cannot separate insects from plants which are their food source. Nature refuses to be divided up in to the convenient slots that humans invent. There is so much for us to discover in the woods, even if some of them are the less attractive members of our fauna.

This impressive longhorn beetle Rhagium mordax does not have a common name, although it is not an unusual species. The larvae feed under the bark of fallen trees and stumps, aiding the decomposition of old timber.

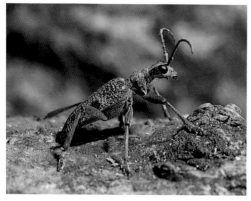

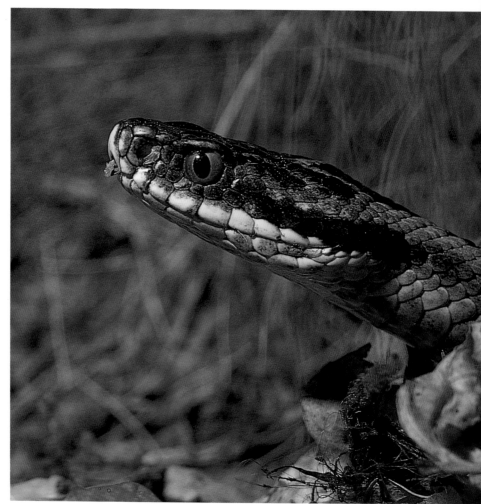

Because the adder is a venomous snake it is a species that is much maligned. In fact it does no harm in the countryside, feeding mainly on small mammals when it uses its poison to immobilize its prey. It will also bite as a method of defence if attacked.

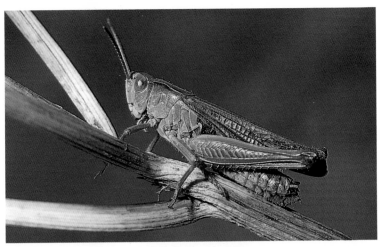

One of the most abundant species of grasshopper is the meadow grasshopper. It is most numerous in areas in course, rough grass and so is easily found in woodland clearings.

The large size and buzzing flight of the cockchafer or maybug may be a little offputting. However, it can do no harm to humans although they do damage crops — the larval stage remain underground for up to four years eating away at the roots.

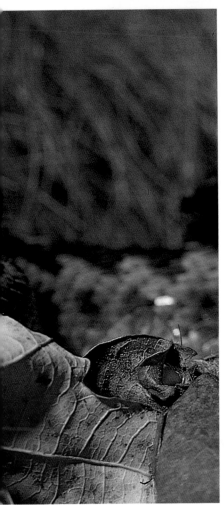

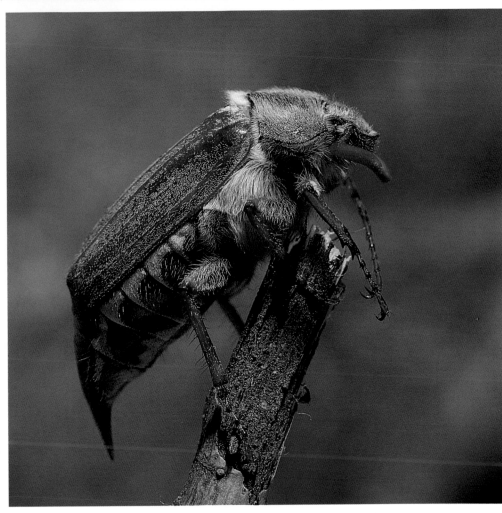

As spring merges into summer it is impossible to find a bare patch of earth. Every square centimetre is covered by the prolific growth of plants. Hundreds of different species are involved in the woodland ecology, from mighty oak trees to delicate violets. Many species make use of insects to do the work of pollination and so they produce a bewildering variety of flowers to attract them.

Many of the smaller flowers are overlooked, but enlarged with a magnifying glass there is astonishing beauty to be discovered in even the most simple flower.

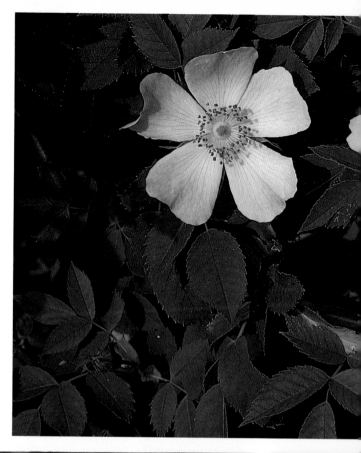

60

Sometimes common dog violets can form large clumps with a dozen or more flowers crowded together.

Dwarfed by the towering trees, a sweet violet looks so fragile in the woods.

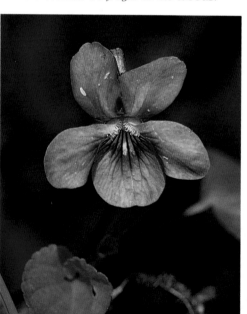

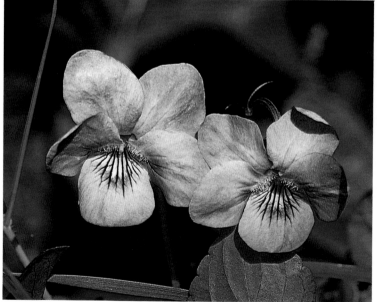

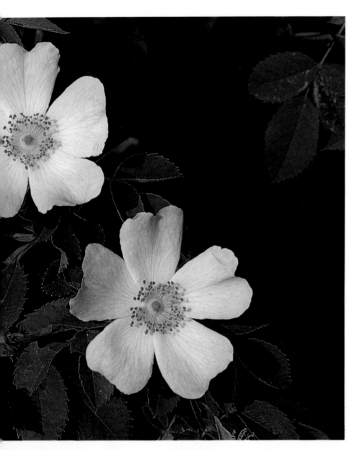

Pale pink flowers of the dog rose brighten the wood. They are easily recognized, being so large and attractive.

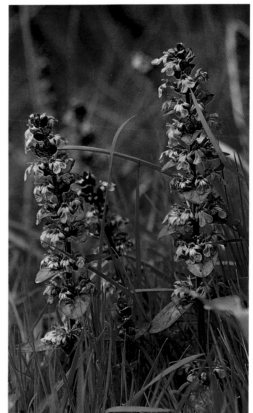

Almost lost amongst the grasses, bugle lifts its flower spike as if begging the attention of insects.

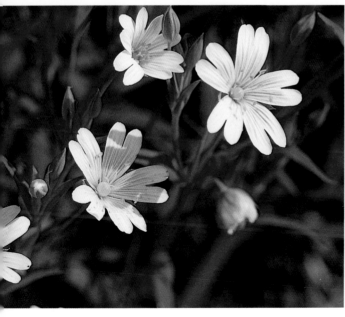

Trembling in the breeze the delicate white flowers of greater stitchwort wait to be pollinated.

As the sun sets in the sky the mystery of the night takes over the wood. Bent and twisted shapes of trees take on an eerie life of their own and the slightest sound of a falling twig becomes the movement of some strange creature. In the gloom of a moonlit wood it is easy for the imagination to invent a million reasons to be on edge; but the truth is just exciting.

I never tire of waiting silently in the darkness for an hour or two, listening to the sounds of the night and straining my eyes for signs of movement. To be rewarded by the sight of a badger on its nocturnal ramblings is an amazing experience.

The obvious place to watch badgers is outside a sett where most activity takes place. Having been underground all day, when they first appear they often spend several minutes grooming. From May onwards the cubs begin to tumble out of the sett each evening, playing with each other and with their mother. Once the badgers leave the sett on their nightly journey they are much harder to observe even though they follow well-worn paths.

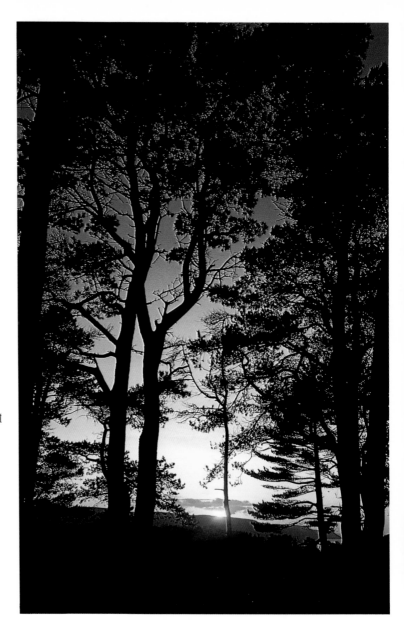

Every tree trunk, branch, twig and leaf becomes a black silhouette against the setting sun. It will not be long before the creatures of the night are on the move.

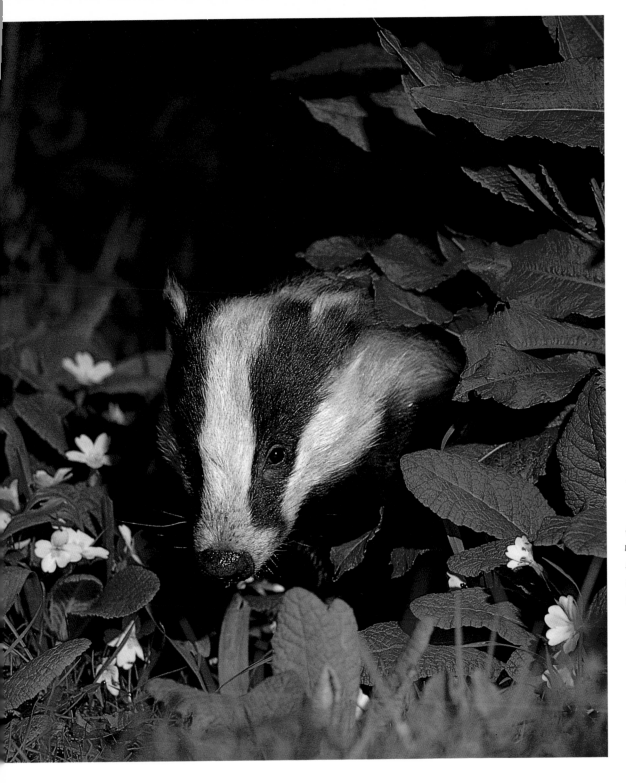

Secretive, mysterious and nocturnal; badgers seem able to maintain their wild charm even though they have been well studied and a great deal is know about their life and habits.

The expression says, 'as cunning as a fox', and it reflects something of the human attitude towards foxes that has continued for hundreds of years. Today people either love them or hate them, depending on their circumstances. Red foxes are still regarded as a pest by many people, even by some who have no direct involvement in farming and who have never been harmed by a fox in their life.

In general, the problem is not with the fox but with humans. The fox is an opportunist, and will feed on anything edible from rabbits to rubbish, worms to weasels, fruit to fish and of course pheasants or chickens.

If I hang peanuts up in my garden I expect blue tits to feed on them, and if they don't, I am disappointed. So if I fill a pen with chickens, can I not expect a fox to feed on them? Understandably a fox will feed on the most abundant food source and if humans create that food source, who is at fault?

On the other hand some of us who enjoy foxes need to understand commercial pressures in agriculture. Whatever our views the sight of a wild fox will always stir a few emotions.

64

Persecuted for generations, the red fox is adaptable and quick-witted enough to thrive. Not only is it a beautiful creature but it also carries with it a sense of the wild wood, before humans ever invaded its habitat.

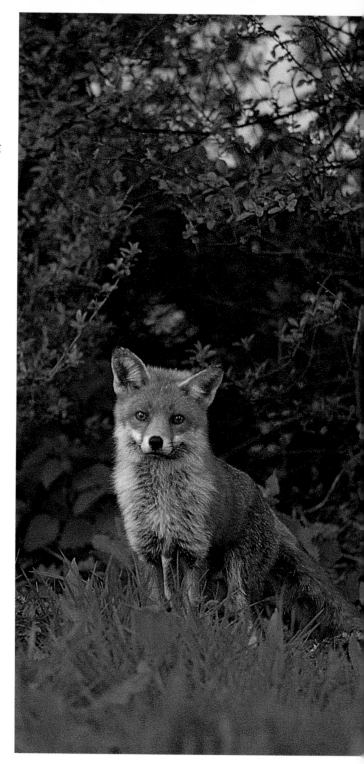

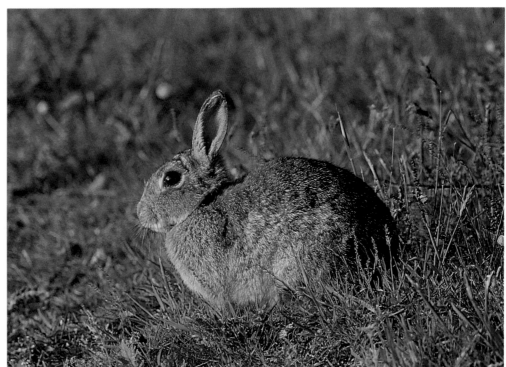

Even though rabbits are a major food item on a fox's menu, they certainly do not live in fear of foxes. The rabbit is well aware of its own ability to escape and will often permit a fox to approach surprisingly close. If a rabbit is aware of a fox's presence, the fox has no hope of a meal but if the rabbit is taken by surprise then the tables may be turned.

Few would say that creation lacks ingenuity. Plants face the problem of how to distribute seeds over a wide area whilst their roots are firmly embedded in the ground. All sorts of devices are used, involving almost every method imaginable. Plants use wind, water, mini explosions, and they even manipulate birds and mammals to do the work for them.

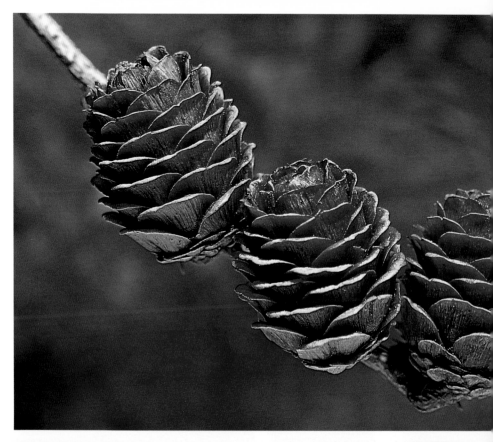

66

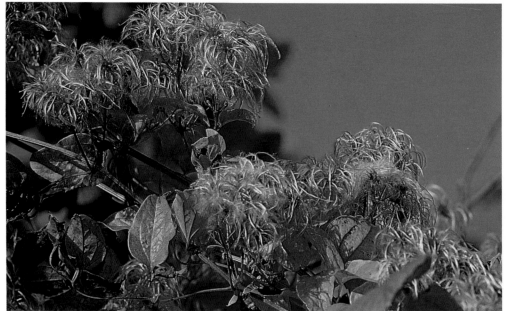

Traveller's joy, or old man's beard, has a solution for long distance dispersal. The seeds are very light and are attached to long feathery awns. They are not easily dislodged from the plant except by a strong wind, which then blows the seeds far from the parent plant.

The seeds of larch trees develop inside cones. As the cones dry the scales separate, which allows the seeds to fall out. Each seed has a triangular wing which catches the wind and can be blown a considerable distance from the parent tree.

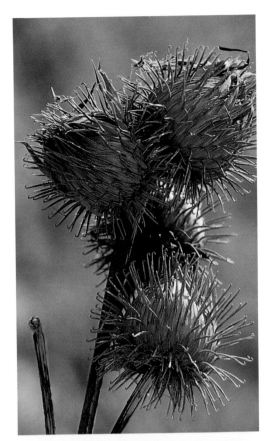

Each seed of burdock has a hook, so that as a passing animal brushes against it the seeds become attached to its coat. The animal may travel some distance before grooming and the seeds are dislodged in a new area.

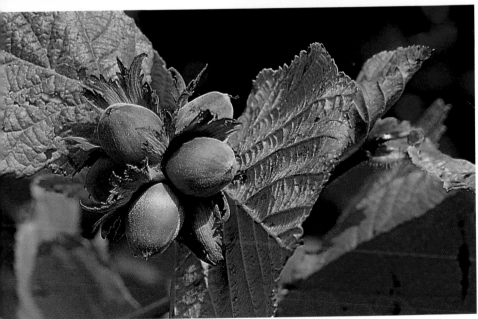

Hazel produces a glut of nuts, more than any creature could eat in one sitting. Having eaten its fill an animal such as a squirrel, magpie or mouse harvests the rest and carries them off. Usually they bury them for later but not all are found and some will germinate in new territory.

What the weasel lacks in size and weight it certainly makes up in ferocity. It is a member of the Mustelidae family and, along with stoats, is often common in the woods. Other members of the family include the rare pine marten, polecat, otter and, largest of all, the badger.

All one usually sees of weasels and stoats is a brown creature, streaking across a woodland path several metres away. However, both of these species are very inquisitive. It is possible to wait, absolutely still, until their insatiable curiosity makes them come to inspect this strange human creature that has entered its domain.

Closer inspection shows how incredibly quick their reactions and movements are. Even with their short legs they run rapidly, often bounding through the woods with arched back.

Weasels are smaller than stoats, but a better distinguishing feature is that a stoat has a black tip to its tail, which the weasels lacks.

68

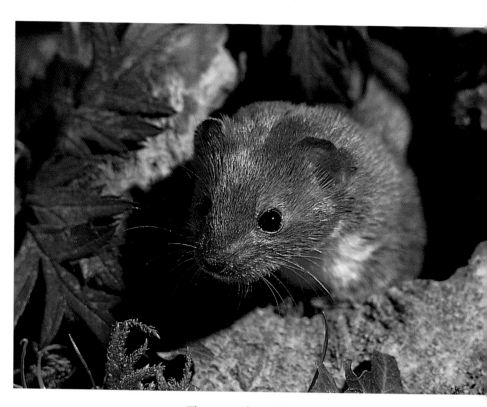

The weasel's quick movements ensure that they have no problem catching mice and voles which comprise their main diet. They hunt mainly by sight and scent and will also eat other prey, from rabbits to insects. Their long, slender bodies enable them to enter mole burrows and their agility enables them to climb into bushes in search of birds' eggs.

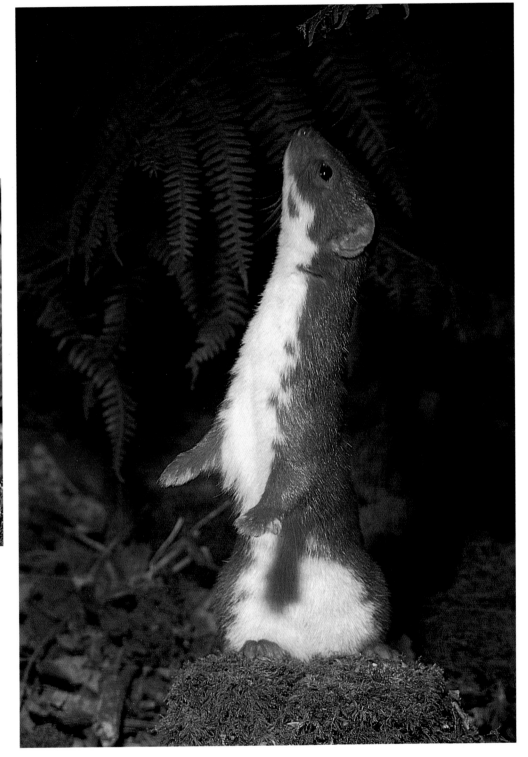

As the weasel scampers through the woods it often stands upright to inspect its surroundings and will take advantage of a log or stump to gain extra height. Any sound or movement is of interest to a weasel — even a roosting bird is possible prey.

69

Spring is a season many of us look forward to but it arrives in different ways for different people. For some it is when birds begin to nest, or it may be when a certain migrant bird first appears. For others it is when buds on the trees shown signs of new life, or blossom covers the bushes. But for many it is the appearance of a favourite species of flower.

Woodland plants take the opportunity of flowering early in the year before the trees produce a canopy of leaves that block out the sunlight. Many of our favourite spring flowers are discovered in the woods.

70

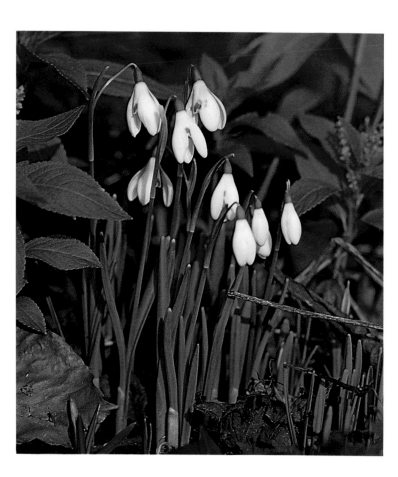

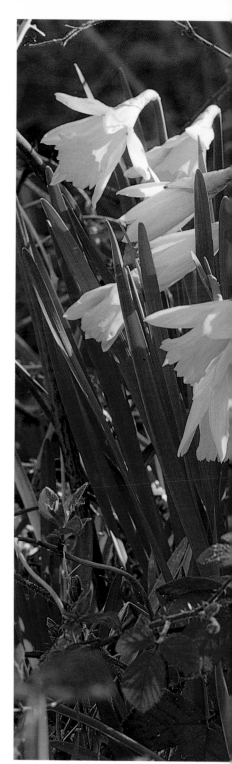

Snowdrops may flower as early as Christmas or as late as March, depending on the season. Each night they close against the cold, opening again by mid-morning. Flowering in the depths of winter they seem to hold a promise of the approaching spring.

Even though daffodils have been cultivated in gardens for many years, wild daffodils are native plants. The trumpet is a richer yellow than the pale outer petals and although they are not as plentiful as they used to be, in some woods they create a wonderful display in spring.

Out of all wild flowers it is probably primroses that most symbolize spring. The pale yellow flowers usually first appear in February and by the end of March banks of primroses are at their best.

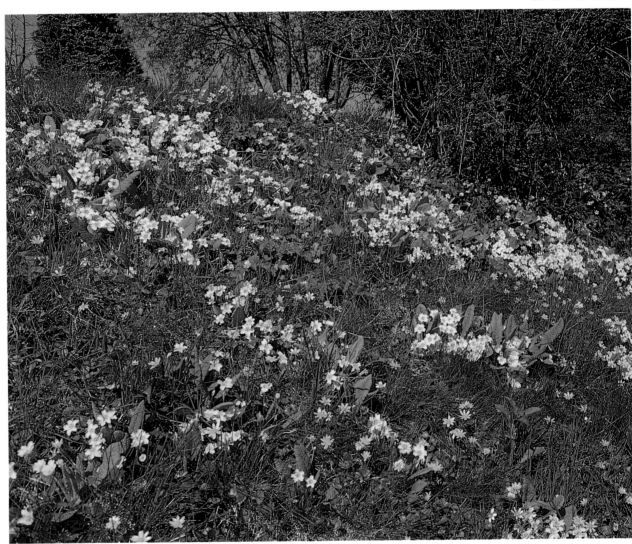

Two birds that are strongly associated with woodland are the redstart and pied flycatcher. Both of them are migrant birds arriving in the spring to nest and raise their young in our woods. They arrive from tropical Africa to feed on the bountiful supply of insects and use natural cavities in trees and so on as places to nest. Why should a bird fly so far to breed? Are there no insects or nesting cavities in Africa? Part of the reason is to make use of the very long summer days in higher latitudes.

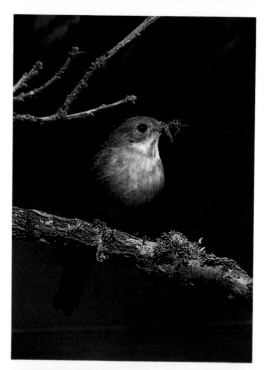

The different plumage of the male and female pied flycatcher can give the impression of separate species of birds. The contrasting black and white plumage of the male is unmistakable but the female is unobtrusively coloured olive-brown and off-white. It is not uncommon for a male to have more than one mate, so when they have young to feed they are kept very busy finding a supply of insects amongst the leaves.

72

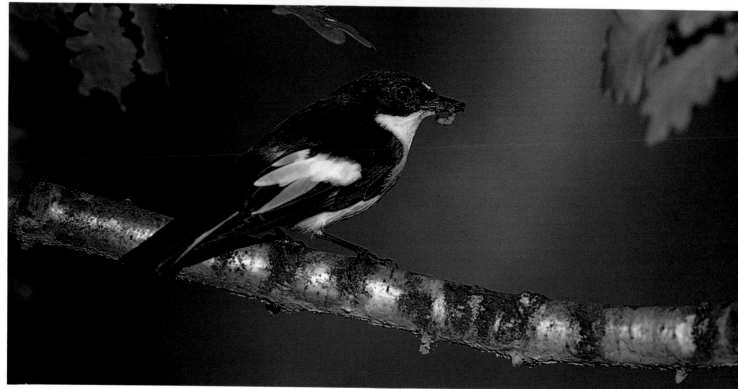

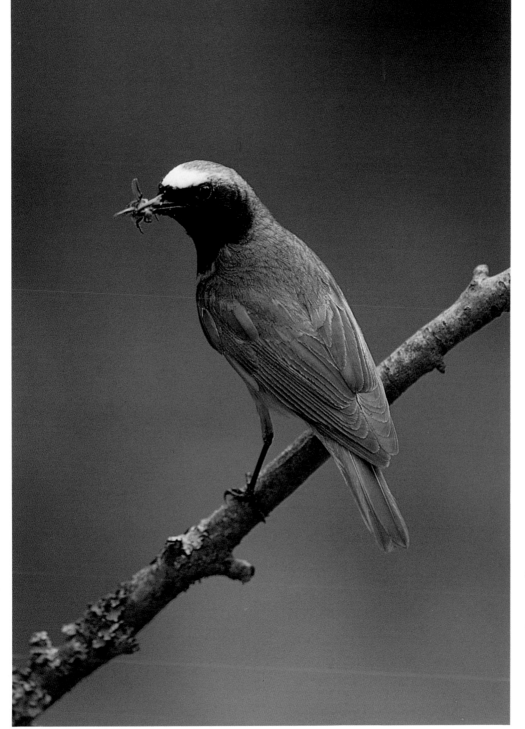

Male redstarts are splendid, smart birds and although the female is less distinctive she still has the typical redstart, orange-chestnut tail. The tail is constantly quivered up and down and is the feature that gives the species its name. It feeds lower to the ground than many other woodland birds and often perches on exposed branches, habits that enable them to be observed.

The tit family feeds on bird tables or peanuts in the garden. However, their wild habitat is woodland where they are wonderfully designed for life amongst the slender twigs and quivering leaves. They are agile little birds, flitting through the canopy, searching every nook and cranny, even turning upside down as they search for food. Tits are mainly insectivorus birds, but during the winter insects may be difficult to find, so they supplement their diet with seeds and nuts and this has lead them to discovering the easy pickings of a bird table.

All tits nest in holes in trees or similar cavities. They skilfully time their egg laying so that the young coincide with the hatching of moth caterpillars that feed on the trees. They raise large broods of chicks each year, sometimes over a dozen, but mortality is high and usually only one or two survive to breed the following year.

74

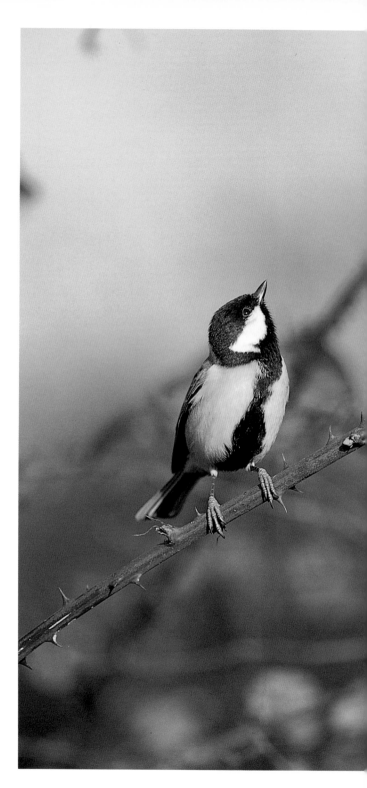

Largest of the family is the great tit. Being heavier it spends more time on the ground where it forages amongst the leaf litter.

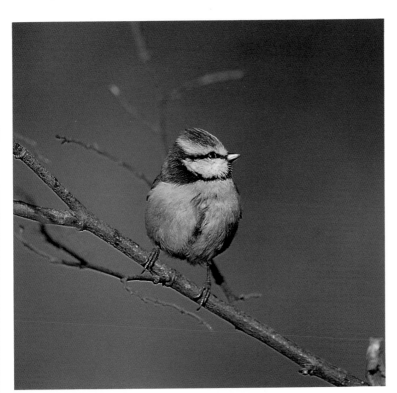

Probably the most familiar member of the family is the blue tit, although they are rather more secretive in the woods than in the garden.

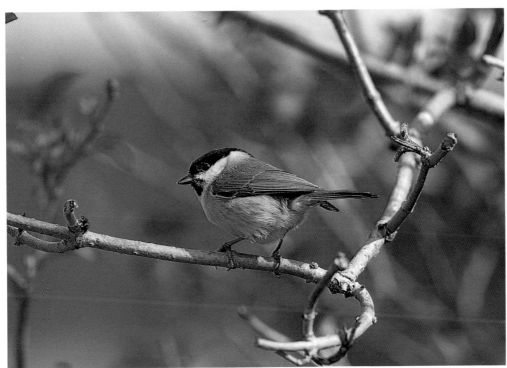

Unlike the other members of the tit family, willow tits excavate their own nest holes, usually in the very soft, rotting wood of birch or willow.

Many woodland birds could be described as familiar friends because they have learned to associate with humans in gardens. Of course those birds with distinctive plumage, such as robins or blackbirds, are recognized by nearly everyone who has a passing interest in the natural world. Within the woods there is a good supply of invertebrates as well as berries and seeds, so that a great diversity of species are catered for.

Dunnocks are sometimes referred to as hedge sparrows even though they are unrelated; perhaps it is because they are small and brown. They tend to be rather secretive, usually keeping in thick cover low to the ground

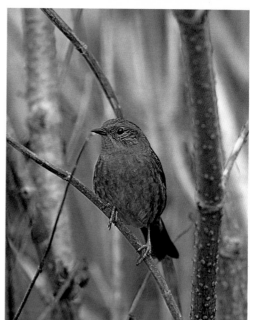

76

One of the most common species to be found in Britain is the chaffinch. It is mainly a seed eating bird and is in no way limited to woodland, being found from mountain top to river valley.

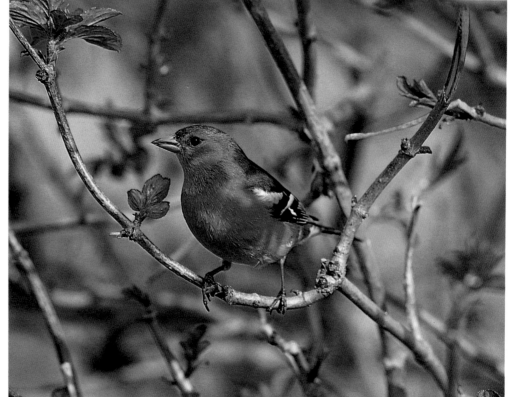

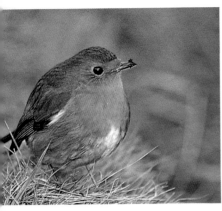

Most familiar of all is the robin. Although British robins are often very tolerant of humans, on the continent they are one of the most shy and wary birds of the woods.

The coal-black plumage of the blackbird is probably as well recognized as the robin. However, the female does not share the male's distinctive feature because she is dressed in a pattern of dull, dark, browns.

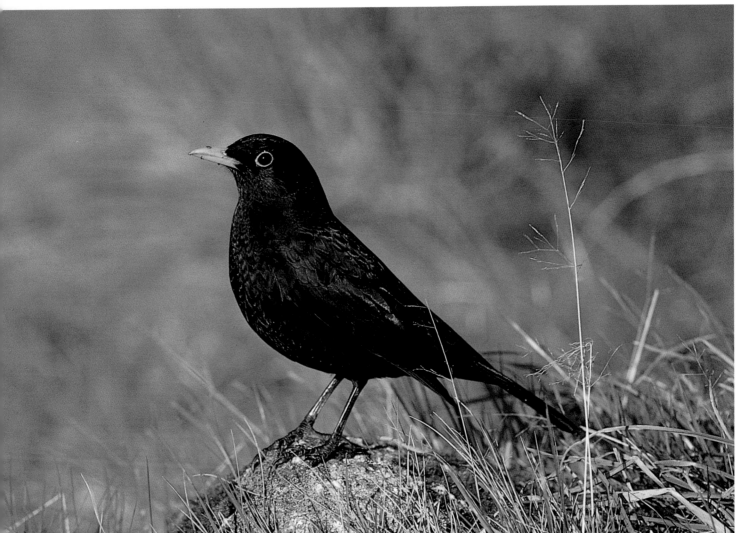

Many species of birds use the security of the woods to nest. The aim of the smaller species is to hide or camouflage its nest from predators, and the bird's survival depends upon this ability. As a result, nests are hidden away in the most obscure and difficult places to find. Some nests are hidden on the ground where the vegetation is thickest, others are high in a bush where the predators are fewest. Some may be placed in inaccessible locations, whilst others may be so well hidden it matters little where they are.

Each species has its own preference but the remarkable thing is that a blue tit never nests on the ground and a wood warbler never nests in a hole; each species instinctively follows the example of their parents.

The most narrow crack is enough to allow a treecreeper to slip in behind the flaking bark of a tree trunk. In this perfectly camouflaged location the treecreeper creates its nest.

Willow warblers make nests out of dead grasses and leaves. They are built on the ground and as the plants grow up around it they become very difficult to find.

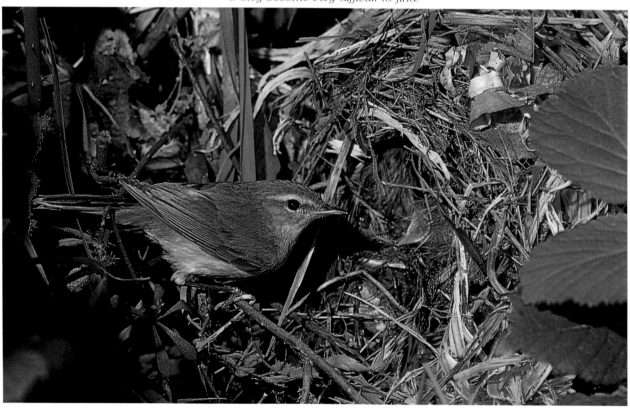

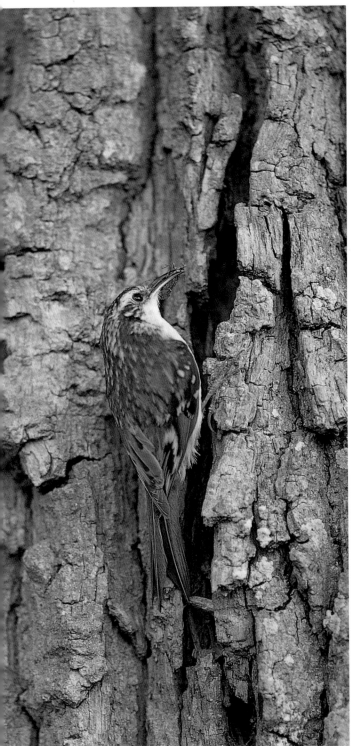

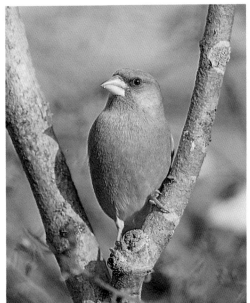

When the greenfinch decides to nest it selects a location little more than two metres high. It will be hidden by thick leaves often amongst ivy but also in trees.

Typically, linnet nests are constructed in a bramble or gorse thicket about a metre from the ground.

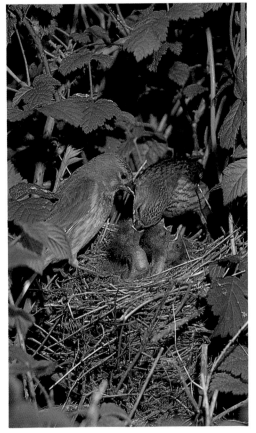

I have heard the long-tailed tit described as being like a flying teaspoon. It is a wonderful description because it reflects something of the affection which many people feel for this bird. It also describes its appearance in flight, its long tail feathers trailing behind like the handle of a spoon. Its popularity is helped by the fact that it is delightfully acrobatic, making it fun to watch and it is more approachable than many other small birds.

The long-tailed tit's most remarkable feature is the nest it creates which is usually located among the thorns of bramble, gorse or hawthorn. It is like a little soft ball with a side entrance hole. It is made out of moss, cobwebs and hair, decorated with lichen on the outside and then lined with hundreds of feathers. Often, ten chicks can be raised in this nest and a second brood will usually be attempted as soon as the chicks have fledged. However, mortality of these tiny birds is high and only a couple will survive to replace their parents the following breeding season.

Once the main construction of the nest is completed, the long-tailed tits become obsessed with feathers to line it. It has been claimed that a nest may be lined with over two thousand feathers that are carried singly to the nest.

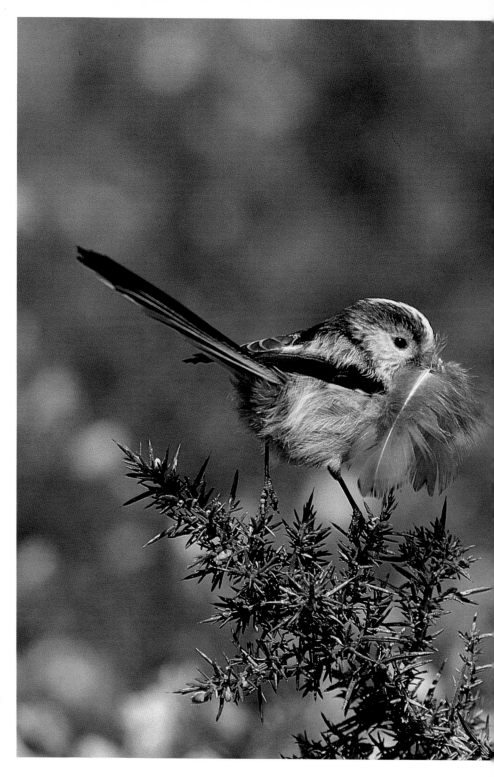

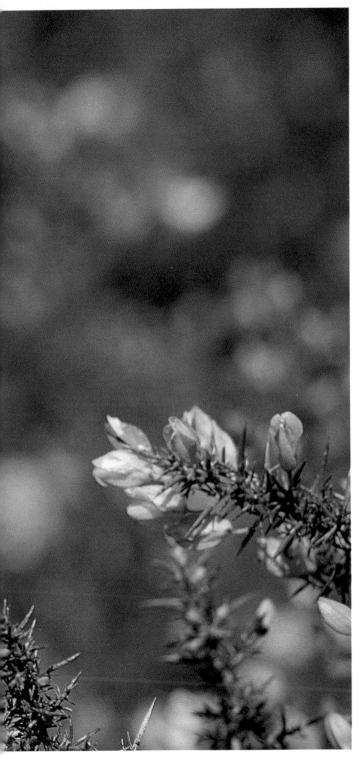

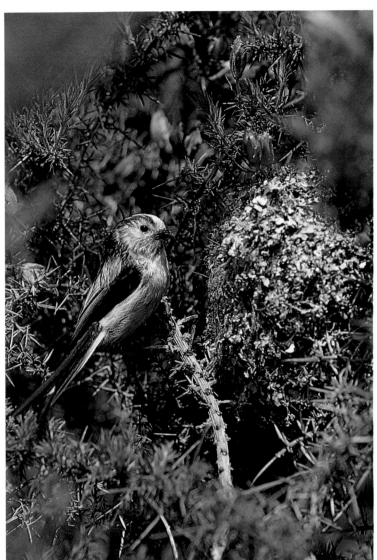

The long-tailed tit covers its nest with thousands of pieces of lichen which acts as an effective camouflage. Nevertheless the eyes of egg thieving predators are sharp and many nests are lost before the chicks fledge.

Each season brings its own sights, sounds and smells. Dewy, mist-laden mornings may be typical of autumn, when colours and sounds are muted. But equally typical are the clear crisp days when vibrant colours of the season are exaggerated by the blue sky and sounds are carried on the still air.

For most of the year the bright colours of a cock pheasant look out of place in the woods (as indeed they are as pheasants were introduced to Britain about a thousand years ago). However, for the few weeks of autumn its gaudy plumage merges with the falling leaves.

During the night, a spider hung a hammock of gossamer in a dead bracken frond. The misty light of dawn illuminates silvery dew drops that decorate each thread.

Leaves flutter to the ground and lie deep on the woodland paths in the autumn months.

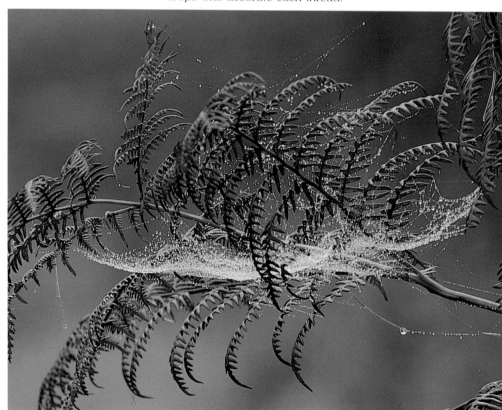

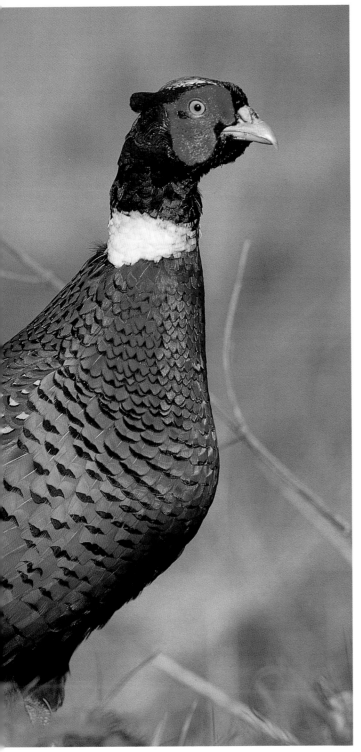

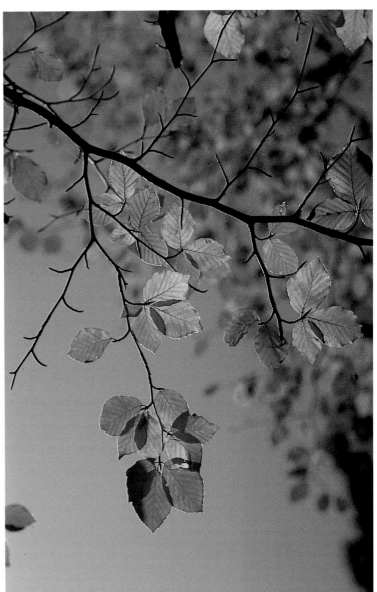

It is not simply death that causes the leaves to turn vibrant with seasonal colour. It is the effect of nutrients being withdrawn from, and waste products being put into, the leaves, in preparation for them being released to the ground.

Both the mistle thrush and song thrush are renowned for their quality of singing. Loud, rich, and with well-defined notes their songs declare territory and advertize for a mate. In many respects the two species appear quite similar, both being brown with speckled breasts. However, the mistle thrush is larger and appears greyer, especially from a distance or in flight.

In general, their nests are constructed in the same way, except that the song thrush skilfully lines its with a smooth layer of rotten wood or dung while the lining of the mistle thrush's nest is of dry grasses. Also, song thrush eggs are an unmistakable clear blue, usually marked with a few dark spots.

RIGHT: Song thrushes tend to nest within a couple of metres from the ground in the cover of hedges, ivy-clad walls and other similar locations. The task of feeding the chicks is shared by the adults and lasts about two weeks until they chicks fledge. Even then the parents will continue to feed them for a further few days as they learn to find their own food.

BELOW: Mistle thrushes usually build nests high in the fork of a tree, often in quite open locations. Three to five youngsters are raised in each brood and once they are able to fend for themselves the adults promptly build a new nest for a second clutch of eggs.

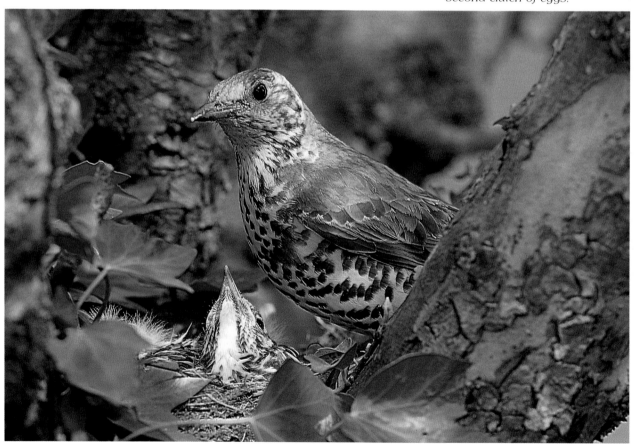

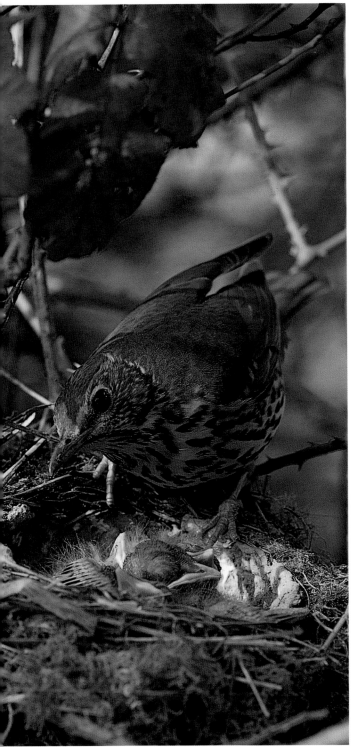

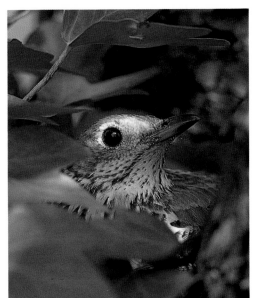

Incubation of the mistle thrush eggs takes about two weeks and during this time the female sits tight, relying on her dull colour for camouflage.

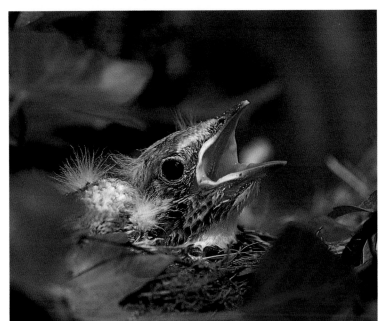

A mistle thrush chick begs for food from its parents. It will remain in the nest for about fifteen days.

Common dormice are
strictly nocturnal but by
sitting just inside a suitable
piece of woodland, with
the twigs silhouetted
against the sky, it is
possible to see this beautiful
little creature as it clambers
through the leaves.

The woodland is alive with small mammals, but because of their size and secretive nature they can go largely unnoticed. Added to this many of them are nocturnal, but they are fascinating little characters.

The most effective way to watch them is to spend an hour or two at dusk sitting quietly in a likely location. Little holes in the ground or runs through the grass may give away their daytime retreat, and other clues are discarded nut shells or nests of shredded dry grass under logs, in bushes, and so on. It may even be worth putting a few peanuts each night in the same place and after a few days keeping watch, but any sounds or movements you make will frighten them away so be prepared to be patient.

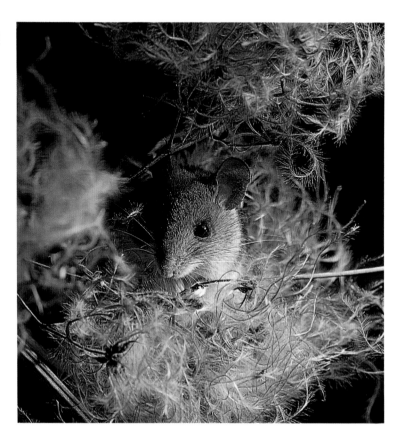

Yellow-necked mice
are strong and agile
climbers and easily
get into the
branches and twigs
in search of food.
Settling itself
amongst the
feathery fruits of
traveller's joy, or old
man's beard, it
spends several
minutes feeding on
the seeds.

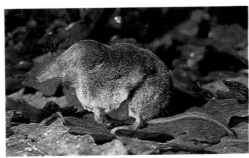

A pygmy shrew is the smallest British mammal but because it is active during the day as well as at night it is more likely to be seen.

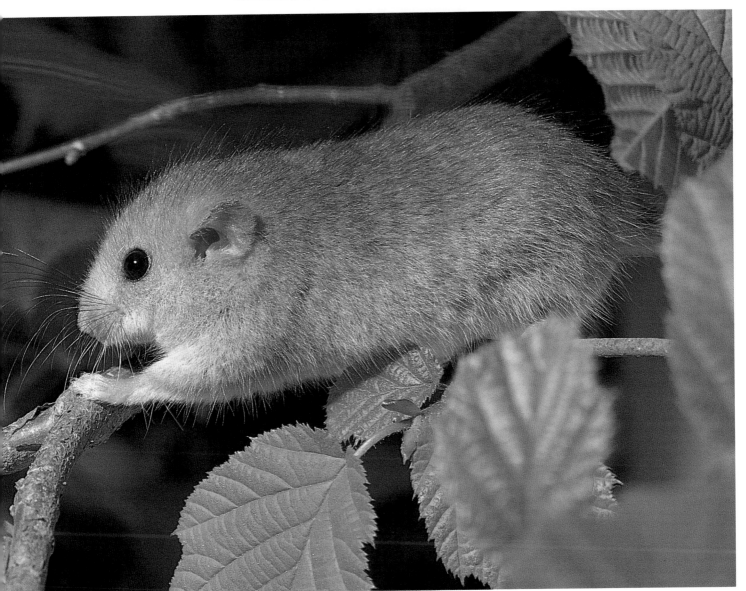

reat tits are cavity-nesting
birds — they use suitable
holes in trees, buildings and
nest boxes, to raise their young.
These are comparatively secure
locations because few predators are
able to enter the holes. As a result
the young are able to remain in the
nest until they are well developed.

Blackbirds, on the other hand,
raise their young in open cup-shaped
nests, an open invitation to
predators. So as a result their young
leave the nest quickly; they are not
even fully feathered and can barely
fly. But they are safer dispersed
amongst the woodland vegetation
than all together in the nest.

Sometimes it seems as if every
problem in the natural world has a
solution.

*Within only two weeks from hatching, the
blackbird chicks will have to leave the nest.
The adults respond to the constant demand
for food. This enables the chicks to develop
from tiny, naked young, weighing only nine
grammes, to young fledglings that can
flutter and hide in the bushes.*

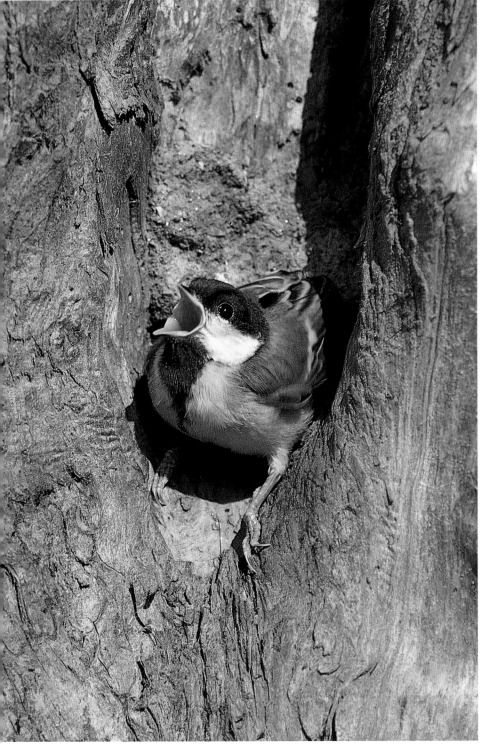

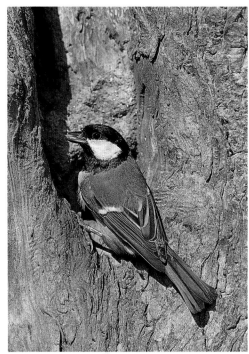

A pair of great tits selected this hole in a tree to raise their family. The adults were kept busy bringing food every few minutes for the demanding young. At last the chicks scrambled out of the cavity and flew. It is remarkable to consider that they had never seen a bird fly in the whole of their short life.

Diminutive harvest mice and grey squirrels are equally agile climbers, each in their own habitat. Although they may share the same wood each of them perceives it in a different way. The squirrel's view is of towering trees, great branches and twigs that are aerial roads to dreys in the heights. The harvest mouse rarely climbs more than a couple of metres above the ground and the trees are replaced by thistles, teasels, burdock, nettles and shrubs of the wood. Being the smallest British rodent it can easily balance on the most slender stem without breaking or bending it, and it makes a little spherical nest of grass leaves.

Both of these species are active by day, but often harvest mice continue their activity into the night.

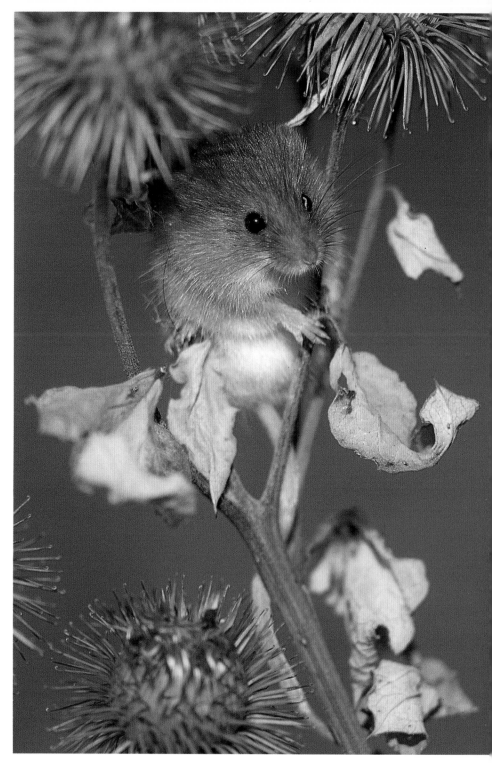

Although it was first introduced only a hundred and twenty years ago, the grey squirrel must be the most frequently observed mammal in Britain. It is familiar to us all because not only have they colonized almost every wood, they have also found suitable habitats in parks and gardens where they often become very tame.

When climbing, the harvest mouse uses its prehensile tail to wrap around the slender stems which gives it extra grip and balance. Not only does it feed on seeds and so on, but it catches a variety of insects. Being so small it needs to eat almost a third of its body weight in food each day to satisfy its energy requirements.

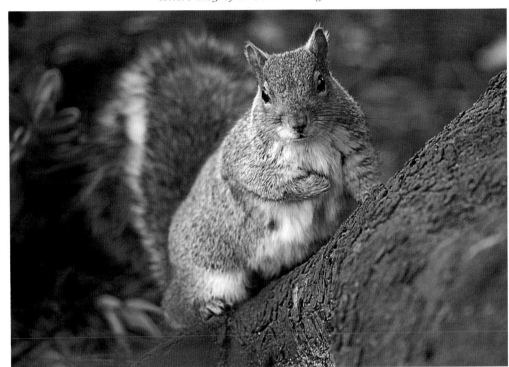

Many people go the woods to enjoy birds, butterflies and flowers, and so autumn can seem like a disappointment. However, there is still plenty to capture our interest because creation never disappoints us. So often we pass things by that we either haven't noticed or are so familiar that we ignore them.

Some people like to list all the species of birds they have seen, or get excited about a good view of a mammal. But how often do we enthuse about dead leaves or even mention the roots of a tree? Perhaps its just a different way of looking at the world that surrounds us.

92

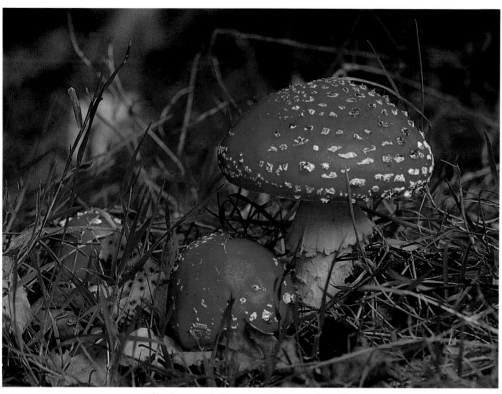

The fly agaric is one of the most easily recognized fungi — which is all to the good because it is extremely poisonous.

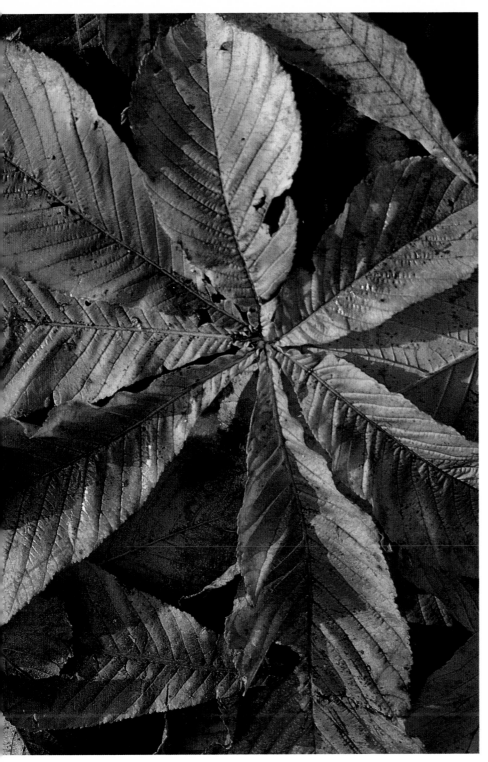

Patterns of colour
and shape decorate
the woodland floor
as horse chestnut
leaves flutter to the
ground.

Massive roots of a mighty beech tree
reach down into the depths of the ground,
supporting a great tower-block of life.

Index to Photographs

Acknowledgments

It all began as I sat across a desk from Rebecca Winter at Lion Publishing. I had suggested the idea of producing a book as a celebration of God's creation, and I proposed several chapters. Rebecca shared my enthusiasm and we agreed on a completion date. I was then taken by surprise when Rebecca asked if, rather than just one, I would photograph and write a set of four books, each covering a different environment. This was even more exciting than I had imagined and I eagerly agreed. However, the completion date remained unchanged! So began the most hectic and challenging two years of my life.

As I drove home, I worked out that I had about five hundred working days to photograph five hundred wildlife subjects, and to write text and captions. The four environments I selected were coast, woodland, river and garden, and during the following two years I travelled from the most northern tip of Scotland to Welsh islands, and from the east coast to the south-west tip of England.

The photographic equipment I used included two single lens reflex camera bodies and four lenses — 28mm wide angle, 50mm standard, 105mm macro and 300mm telephoto. Extension tubes, three flash units and cables were the main accessories and every picture was taken using a substantial tripod.

Wildlife photography is more to do with understanding the subject than equipment, and making use of that knowledge to get in close or encouraging the subject to behave in the way you want. Almost all the bird photographs were taken using a hide and small subjects such as insects or mice were photographed in my studio.

Finding some subjects is one of the most time-consuming occupations, and working on private land is a real bonus. As a result I am extremely grateful to the many farmers and land-owners who generously allowed me access to their property. I lost count of how many private gardens I visited for the 'garden' book, and I am so appreciative of the welcome and help I received from people who share my interest in natural history. It is always encouraging when someone else shares your enthusiasm for a project, and I am grateful to C.J. Wildbird Foods Ltd. for providing me with a supply of food to tempt everything from blue tits to badgers, woodpeckers to wood mice.

I also wish to thank the whole team of Lion Publishing who have been not only professional and efficient in their approach but also enthusiastic, which makes them a pleasure to work with.

During the two years I spent working on this set of books I needed to spend many days away from home and usually worked very long hours. Throughout, my wife Janet was always encouraging, sharing my failures and frustration as well as my success and without her support it would have been impossible. To say that I am grateful seems inadequate.

Text and pictures copyright © 1996 David Boag

This edition copyright © 1996 Lion Publishing

The author asserts the moral right to be identified as the author of this work

Published by
Lion Publishing plc
Sandy Lane West, Oxford, England
ISBN 0 7459 3175 8
Albatross Books Pty Ltd
PO Box 320, Sutherland, NSW 2232, Australia
ISBN 0 7324 0879 2

First edition 1996

10 9 8 7 6 5 4 3 2 1 0

A catalogue record for this book is available from the British Library

Printed and bound in the United Arab Emirates

95